ON STELLAR RAYS

A DAD
A DAUGHTER
A DIVORCE

PHOTOGRAPHS

JUSTIN O'NEILL

Foreword | Madeline Lippman, PhD
Preface | Elinor Carucci
Drawings | Stella O'Neill

G ARTS

First published in 2018 by

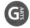

G Arts
600 Third Avenue
New York, NY 10016

www.gartsbooks.com
media@gartsbooks.com

First edition, 2018

Library of Congress Cataloging-in-Publication data is available from the publisher.

Design: Liz Trovato

Hardcover edition
ISBN: 978-0-9987474-9-1

Printed and bound in China

10 9 8 7 6 5 4 3 2 1

For Turtle

CONTENTS

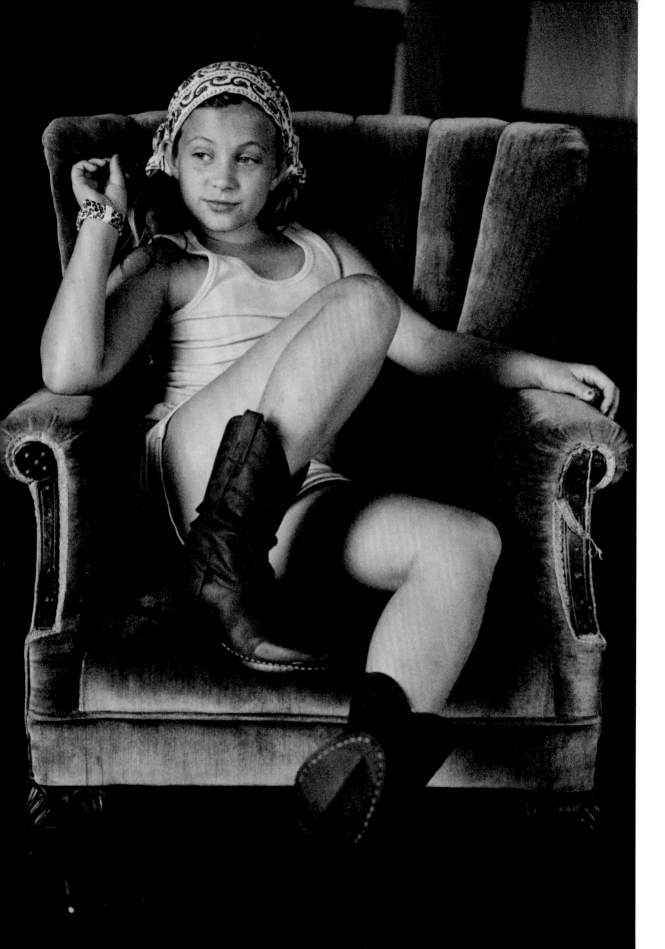

FOREWORD

When Justin invited me to contribute to this remarkable book, I was asked to lend my expertise as a clinical psychologist, to comment on the prevalence of divorce in today's society and the effects of divorce on children and families. The statistics are familiar to us, though still striking: divorce rates are as high as 40–50 percent, and they have a profound impact on everyone involved. But what interested me more than these facts was the way in which creativity can be a response to loss and how it can transform one's experience of loss. That is what this book is about.

 When we look at the stars, whether in a dark sky away from city lights or in the neon glow of plastic glued to the ceiling of our children's rooms, what feelings do they evoke? Wonder, possibility, mystery, magic—the reorienting of ourselves in relation to the universe. On a different landscape, when we lose someone or something we love—in this case the nuclear family as it is forever altered through divorce—the feelings of grief can include shock, rage, terror, emptiness, despair, and displacement.

The beauty of Justin's book is the collaborative creative process that takes him and his daughter, Stella, through grief and mourning to the beginnings of new possibility, from loss to wonder. They both grieve the threesome they knew as they explore a reorienting of who they are individually, in relation to each other, in relation to Stella's mother, and in relation to the outer world.

The moment Justin picked up his camera, he engaged in the activity of making something new out of loss. Maybe he was moved to photograph Stella because the most profound pain a parent often feels in divorce is the fragmentation of their child's world. As an artist he knew, whether consciously or instinctively, that taking pictures could potentially infuse that pain with hope. He wanted to do this for himself and for Stella. He also wanted to understand Stella's experience, to know her in this new role, and to reflect back to her that he could see her.

And how he has seen her! And how she has situated herself to be seen. There is a complex interaction between Justin's interpretation of a look or gesture, his creation of a shot to capture a particular set of feelings, and Stella's increasing participation in this process. He views her through the lens of his own grief, while at the same time he gives her room to be in control in the face of her utter lack of control. He allows her the freedom to explore what she feels and who she is. Most importantly, he lets her know that he has the capacity to hold all of those feelings for her.

For however collaborative this project, Justin is the parent and guide. He is responsible for making their adventure a reparative experience, one that can help establish a new equilibrium. Stella can then play and experiment within

those secure parameters. She can express the galaxy of feelings we see in these images—sadness and stubbornness, vulnerability and defiance, nascent sexuality and childishness, hurt and resilience—within the safe space that Justin has created for the two of them. And in the process of capturing the multiple facets of Stella's experience, Justin is also able to name his own.

Photographs evoke the interplay between seer and seen. What is Stella feeling when she looks into the camera or when she ignores it while engrossed in her own thoughts? What is Justin seeing in that moment? How do his own feelings color his interpretation of hers? What is expressed, and what remains hidden? What is shaped by design, and what is captured unawares?

Each viewer will answer these questions differently based on their own histories and imaginations. The best art leaves room for multiple layers of meaning and exists in the same liminal space between waking and sleep, conscious and unconscious, that the stars on our child's ceiling reflect at bedtime. These photographs invite us into the very personal world of father and daughter as they navigate their loss through seeing and being seen, play and exploration. This is the transformative power of the creative process.

—Madeline Lippman, PhD

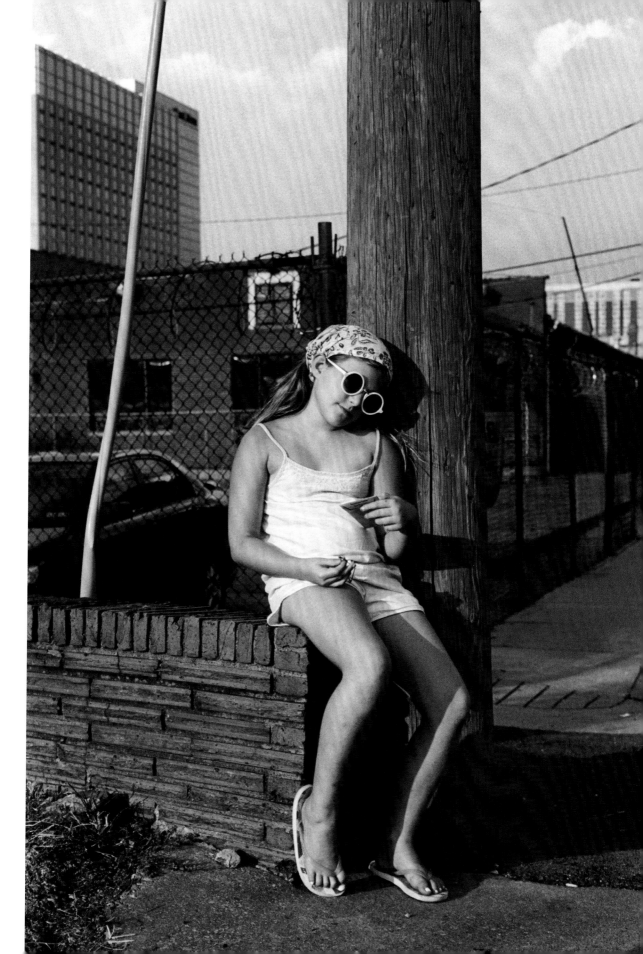

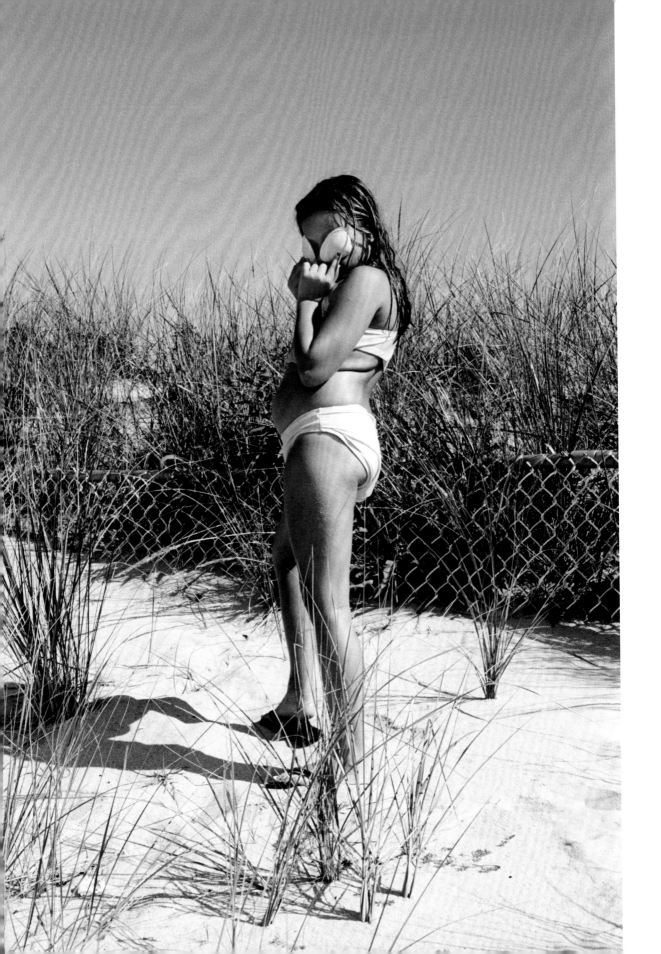

FOLLOWING STELLA'S FOOTSTEPS

Sometimes we have to look to our own children to let us know that everything is OK.

Justin did it with his camera.

After a personal crisis in his marriage, Justin O'Neill turned the camera on his daughter, Stella, to see not only her but also through her: to see the sunlight, the forest, the water, the woman in the subway holding her child, the taste of ice cream—those little beauties of the ordinary that help us get ourselves back. To see Stella's strength, laughter, playfulness, pain, and anger. The magical ability that children have to continue living, moving on, and adjusting.

She inspired him to take pictures, pictures to inspire himself.

As a photographer I very well know the feeling of using a camera in order to see, to feel and understand, and to love again. In this journey Justin took with Stella, they both formed a new family dynamic, with Justin, in a role reversal, letting her lead the way. By following Stella back into the world, he allows himself to see like a child again. To discover. To recover.

In the photographs of *On Stellar Rays*, the beauty of the comforting, yet magical, ordinary can be seen.

Parenting might show us in our worse moments, but it will make us stronger and better, for someone other than ourselves.

> "Sometimes I think the only memories I have are those that I've created around photographs of me as a child. Maybe I'm creating my own life. I distrust any memories I do have. They may be fictions, too."
>
> —Sally Mann

As with other photographers who turned their cameras on their children, such as Sally Mann, Emmet Gowin, and Nicholas Nixon, Justin's work penetrates not only the psyche of the subject—his daughter—but also of the photographer himself.

In some photos Stella is seen making faces and playing in the playground. In others she is angry or upset or contemplating the broken pieces of a wrecked car. Here and there she is with her mother—The Ex-Wife—in the moment before the parents take turns being the parent. This is the family now.

We never get to see Justin, but we get to see his point of view, his gaze, the gaze of a father, of a man, a wounded man, looking for beauty, for comfort, making sure that he is connected to Stella, that he is aware of who she is and how she feels and what she sees as she transitions from childhood to early adulthood, entering the fragile teen years, the beginning of her womanhood and sexuality, something he might have taken for granted before the divorce, before the pictures.

Justin's images have an innocence, but Stella's wounds show as well. Childhood is seen both from within and without in its complexities and layers, the sweetness and the struggle. The border between childhood and adulthood are blurred.

A few days ago I had a tough day with my own thirteen-year-old daughter. I went online to look for some advice on how to deal with what I felt was hatred toward me, and I found this sentence:

> "If you don't have children now, when you have them you will have these moments. When you look at them and your heart—it's like your heart takes all the pain and all the love for them that you have."

Then I went to Justin's images. I just sat there and looked at them, and looked back at my daughter and knew that everything will be OK.

—Elinor Carucci

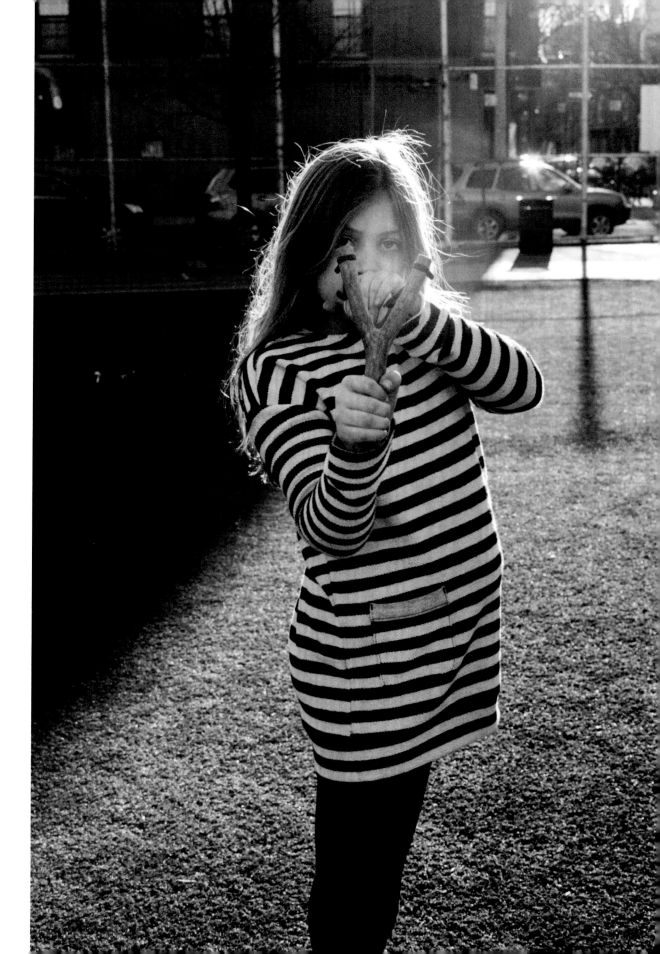

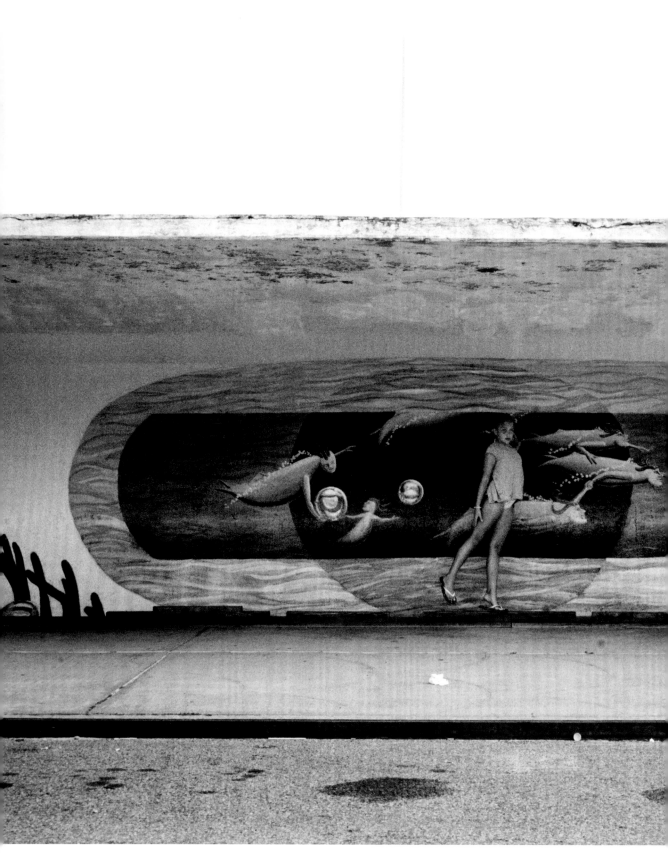

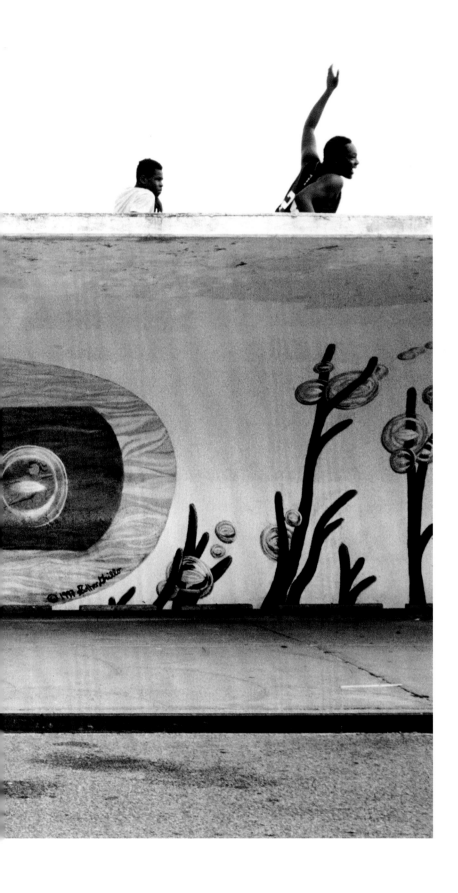

Under the sea, my fish family and me.

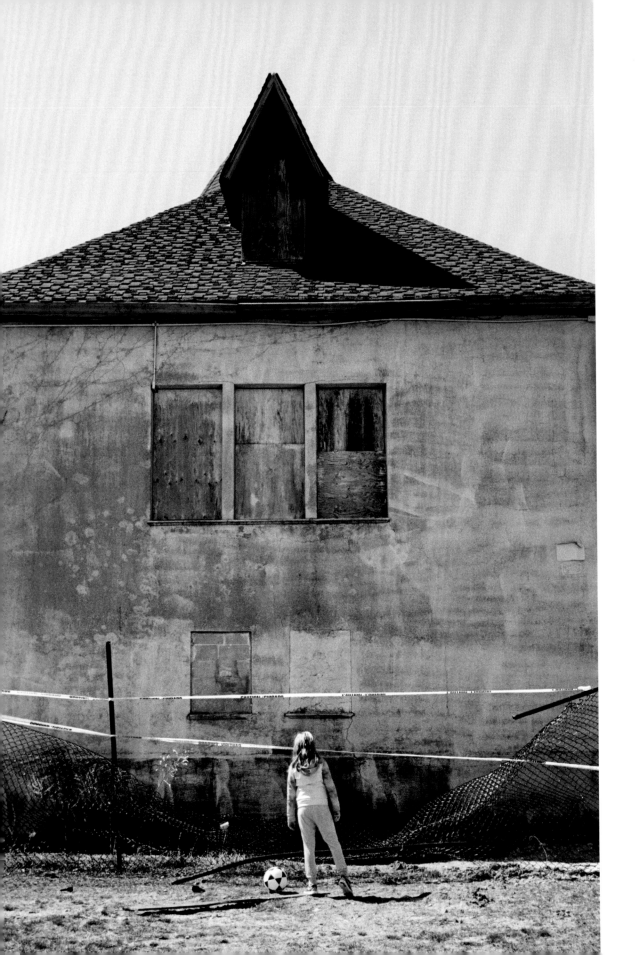

INTRODUCTION

April Fools' Day 2015 for me was no joke: It marked the end of my thirteen-year marriage.

The foundation of my life—marriage, family, and love—felt like it was washed away in an instant. The week afterward I didn't go into work, wandering around in a daze, unsure how I would ever recover.

I felt numb and incapable of making art. Family, friends, and therapy got me through that first year. A few photographer friends encouraged me to pick up my camera and channel some of what I was feeling into photographs. My first attempts were sentimental and a little embarrassing, such as shooting peonies, my now ex-wife's favorite flower, whenever I encountered them. This kind of hopeless melancholy predictably ran its course, and then I turned my attention to where it always belonged—to our daughter Stella.

I decided to photograph Stella as a testament to our survival, together, sharing time with her mother, in our new dynamic. Over the course of nearly three years (starting when Stella was eight), we collaborated, art directed, and developed shoot concepts. We wove narratives with our new visual discourse; we noticed reoccurring symbolic imagery and themes, such as swans, escapism, funny faces, being found, and ice cream vices.

We held each other up with pictures, reminding ourselves through the practice of making art that we are each other's best collaborators, and the best of friends.

—Justin O'Neill

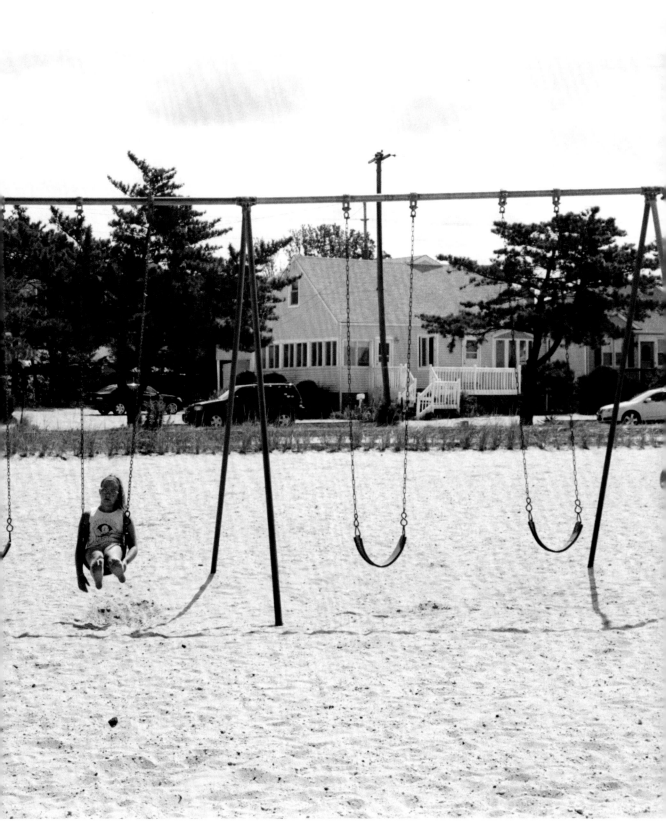

Asleep in sun glare, with golden hair.

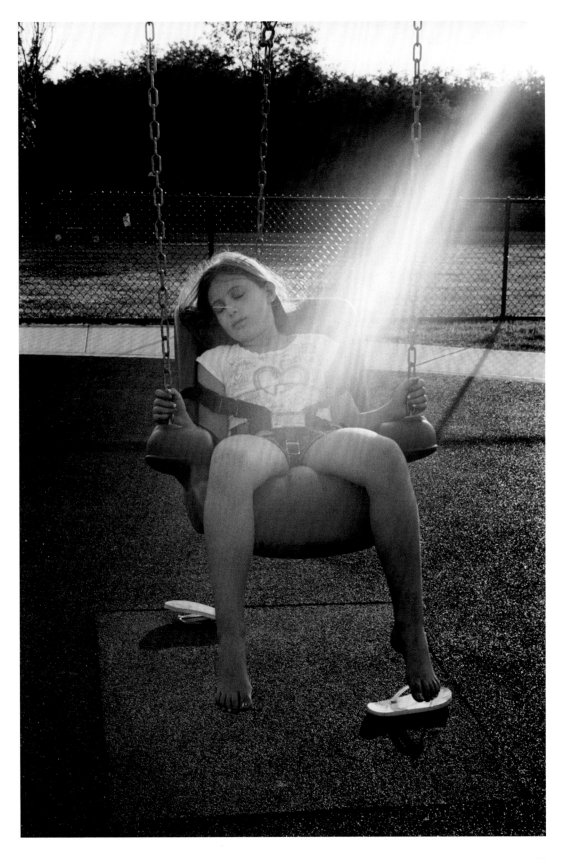

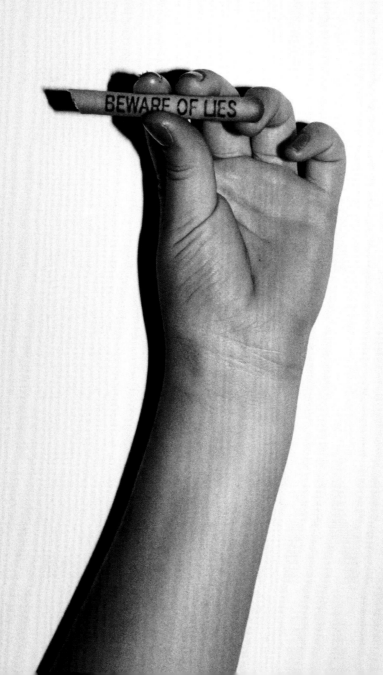

Dark shadows make me scared.

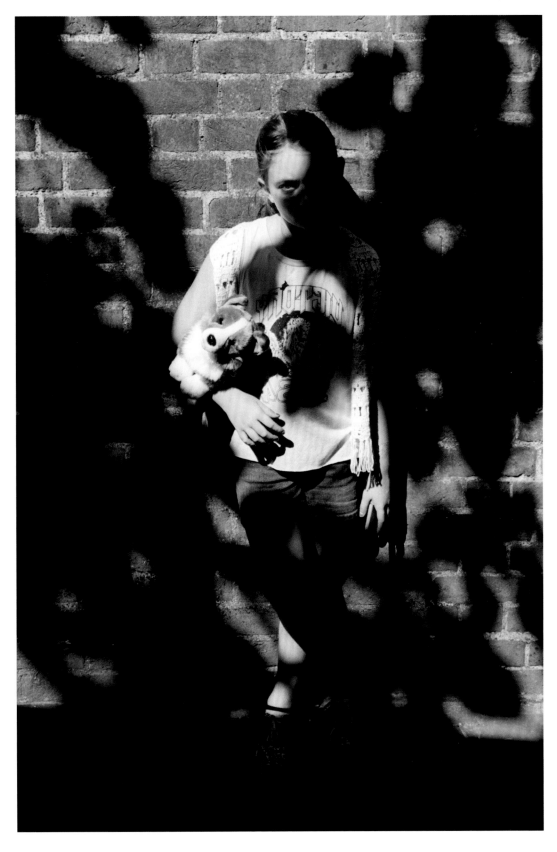

Looking at Daddy through a giant bubble.

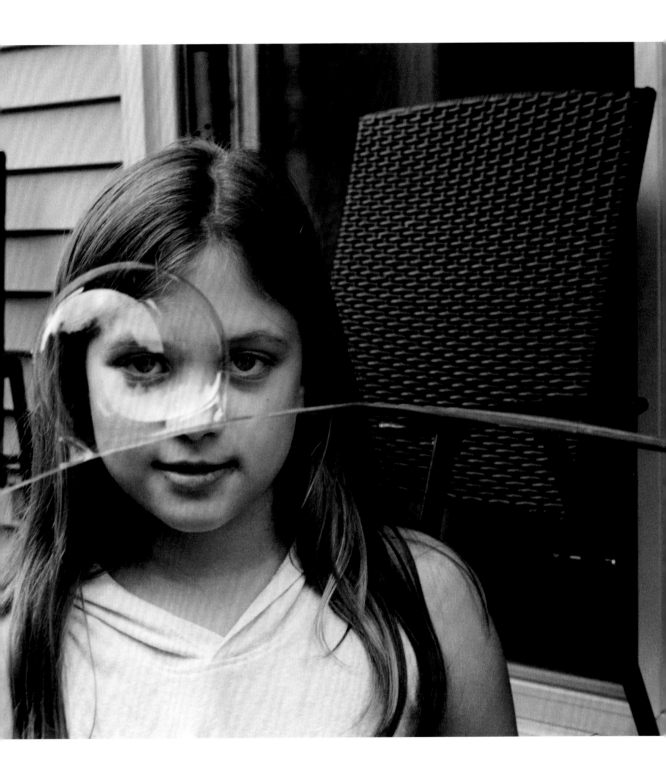

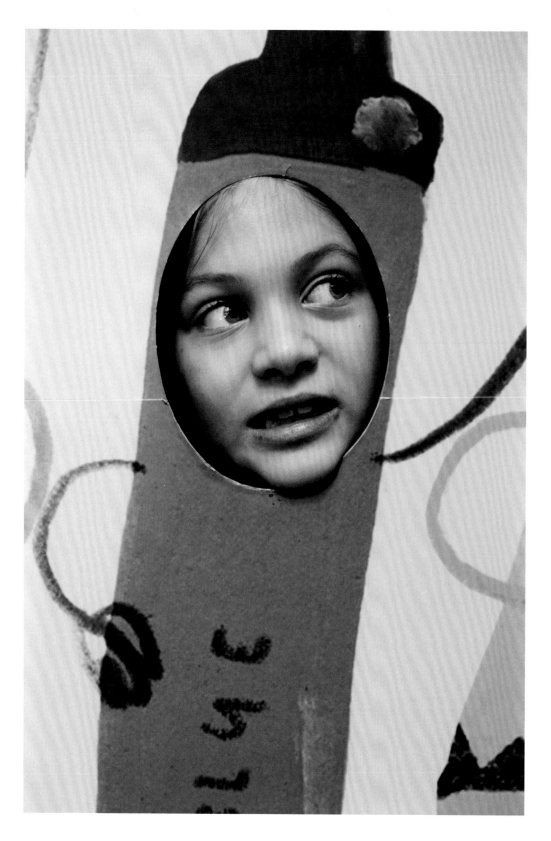

I think the color blue is a sad color.

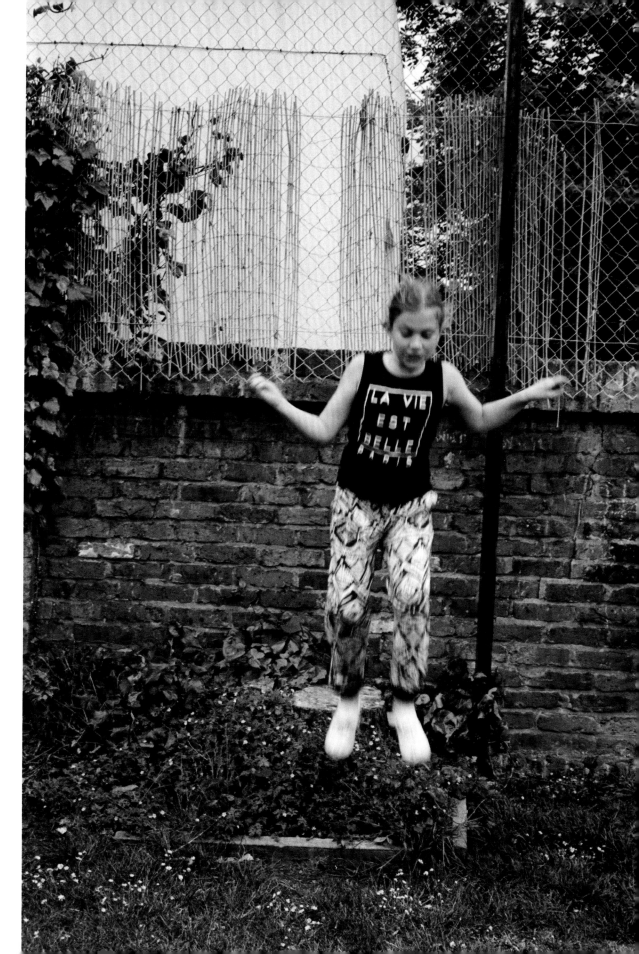

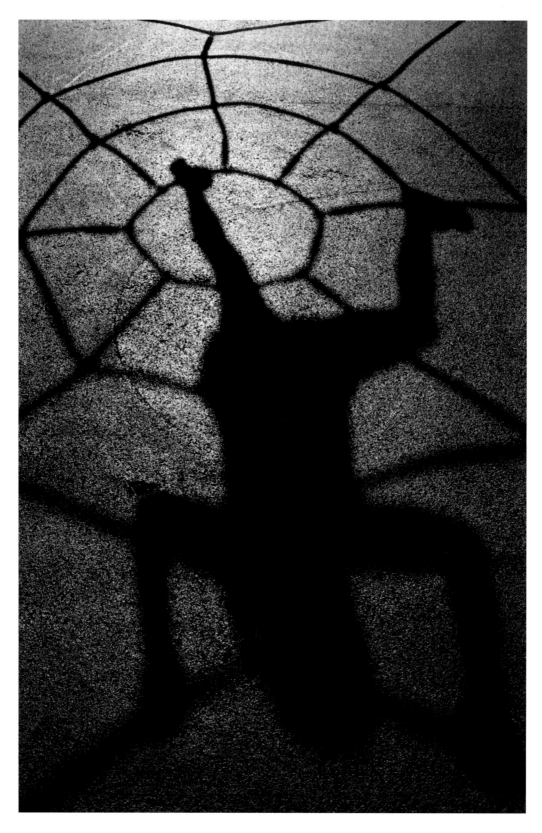

Escaping to the sky.

32

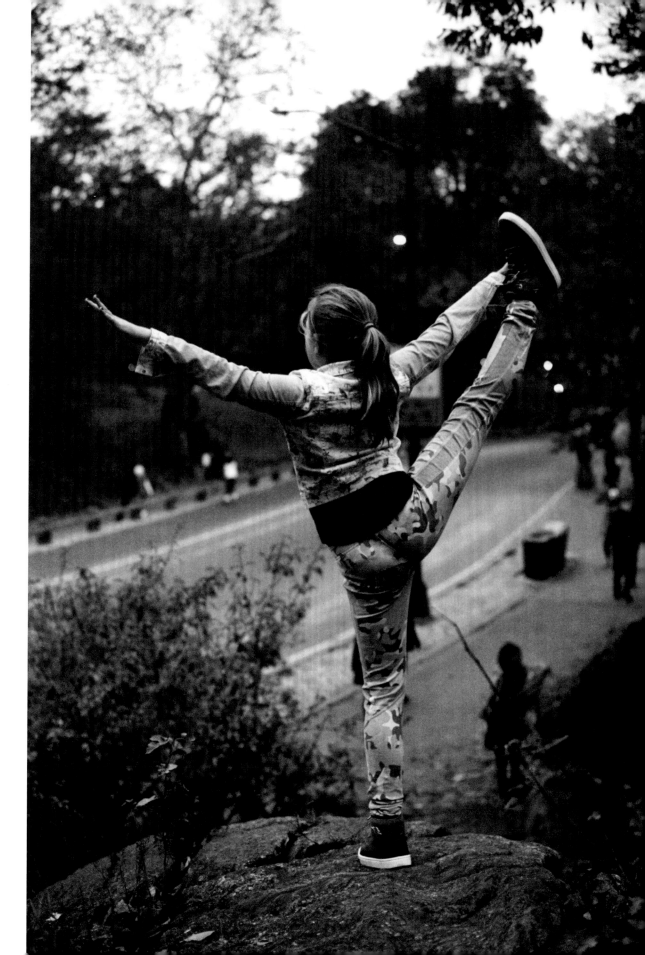

Upside-down smile.

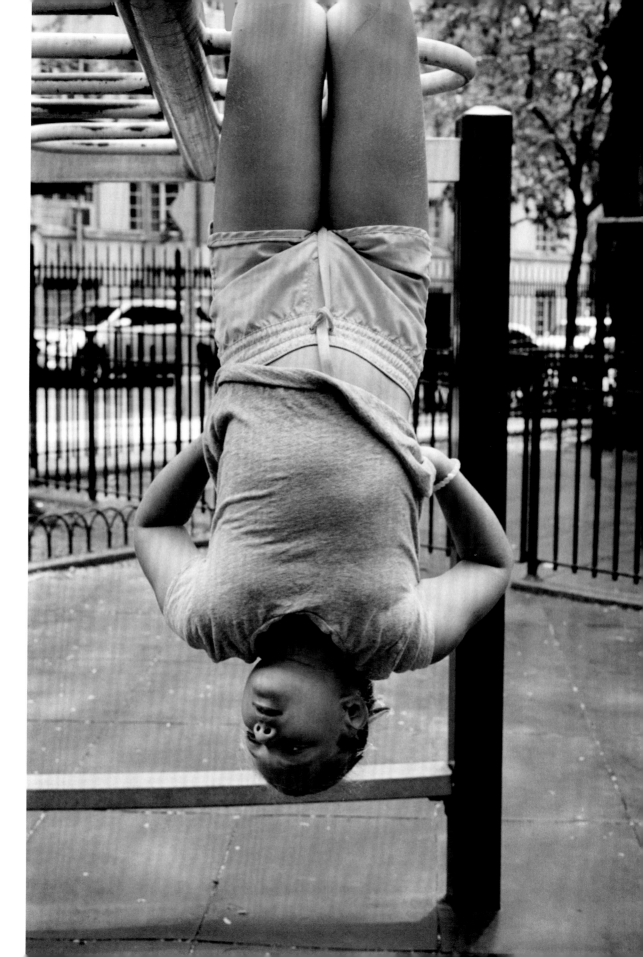

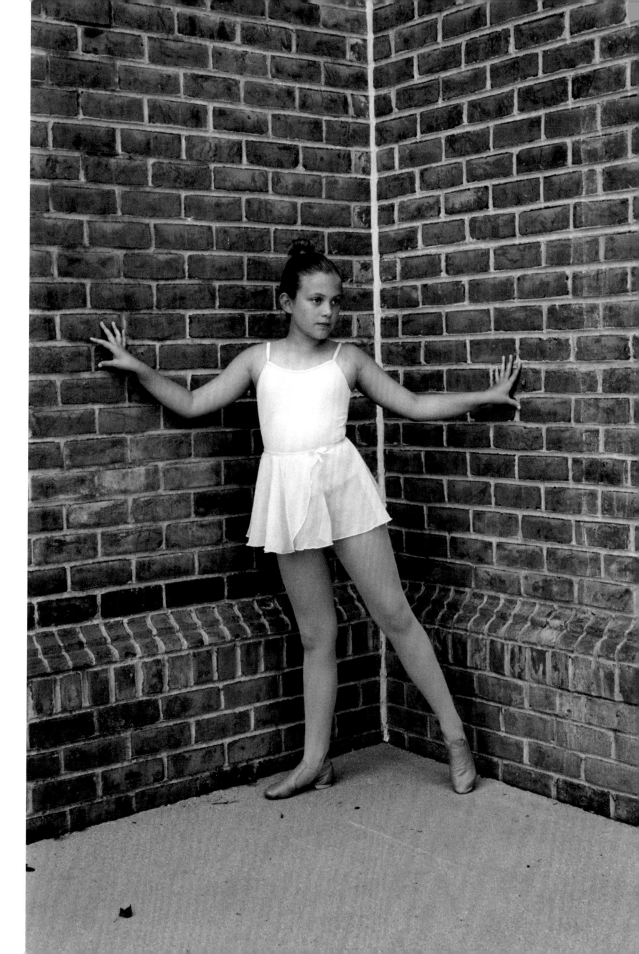

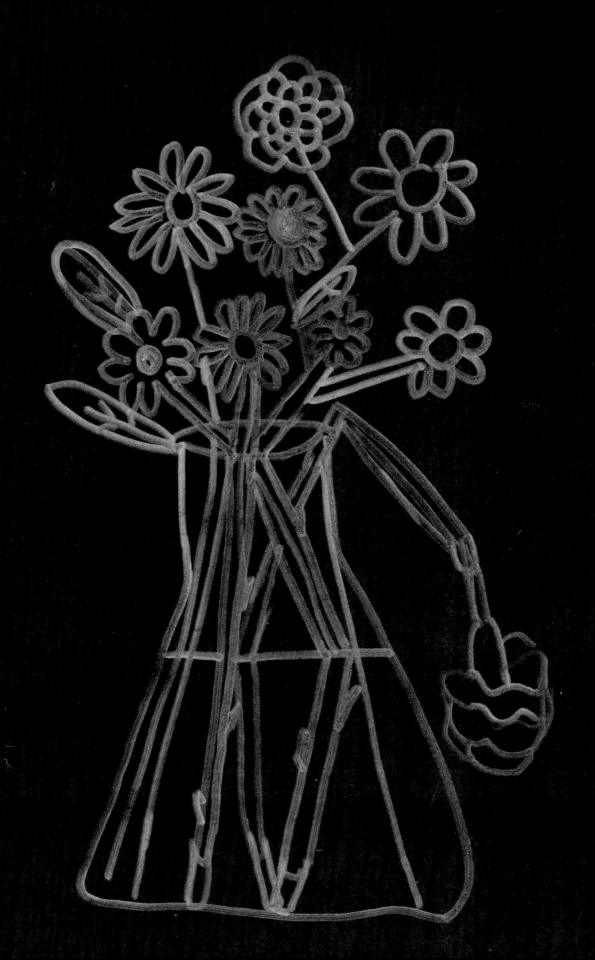

Thinking of them.

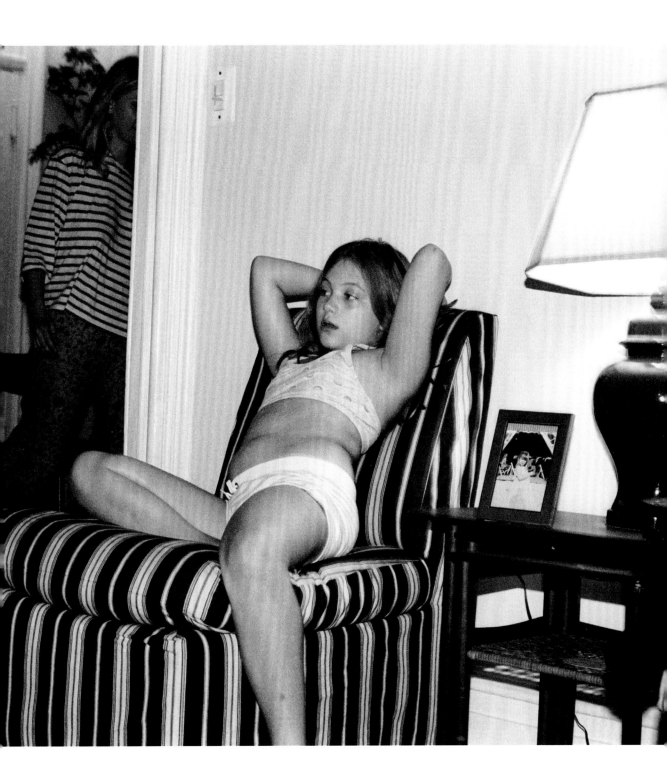

Breakfast and pigtails with Mommy.

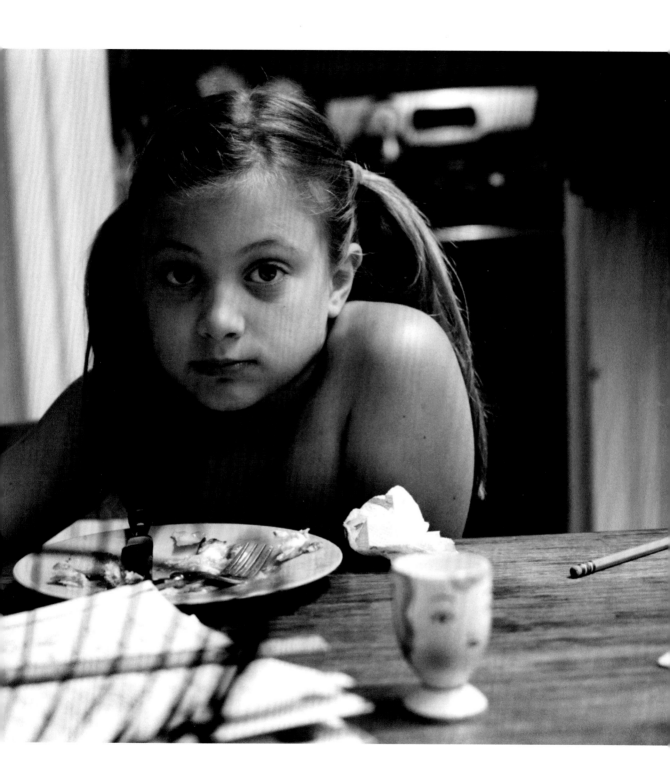

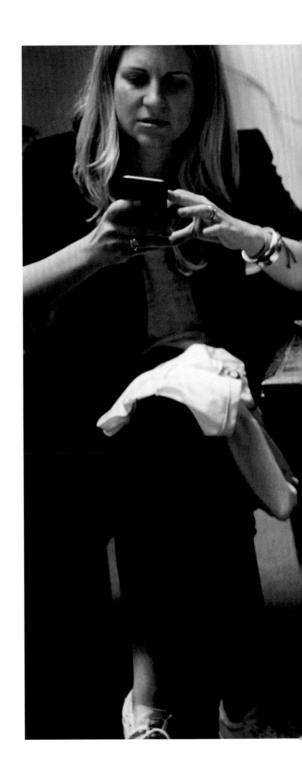

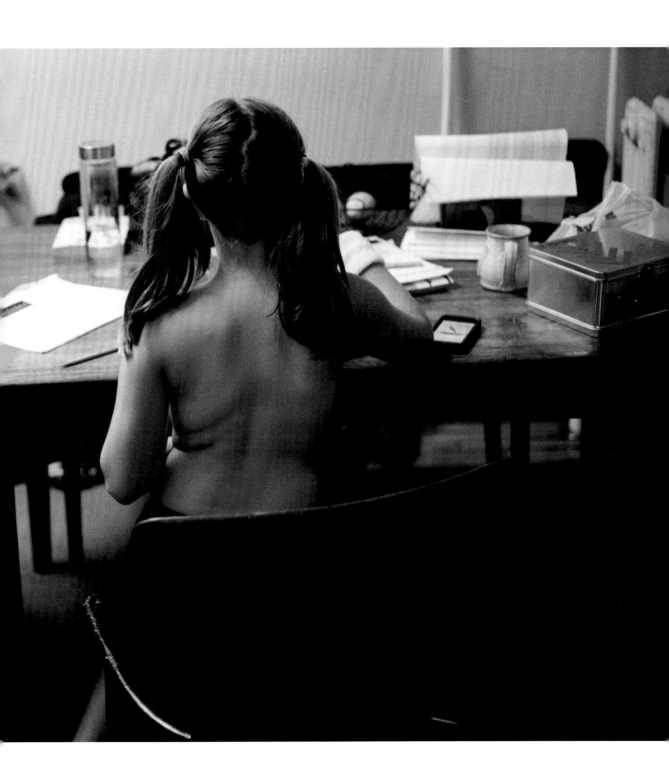

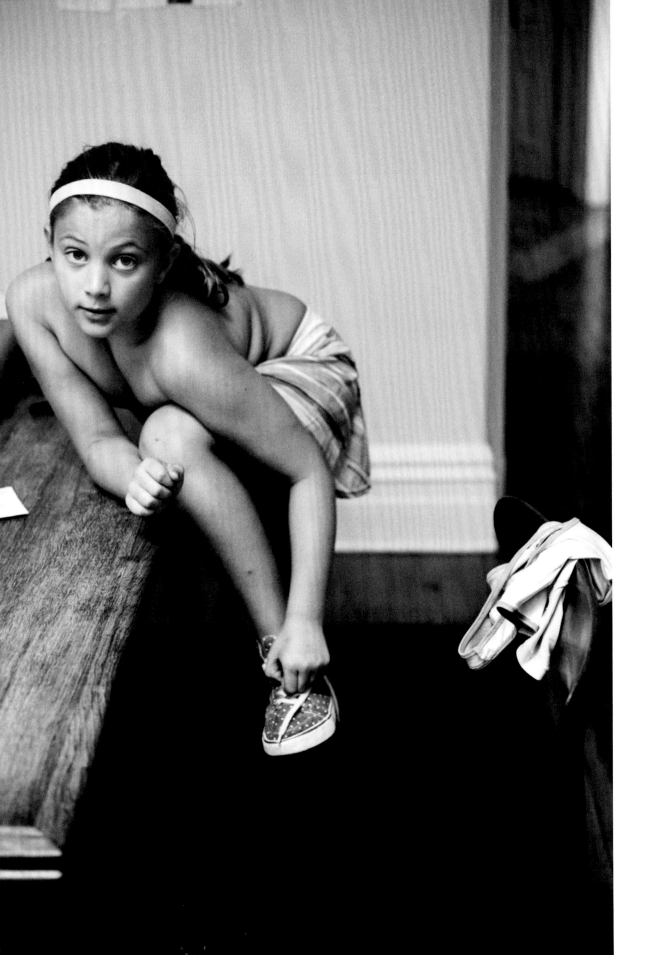

Lace tying; time flying.

Sassy spotlight.

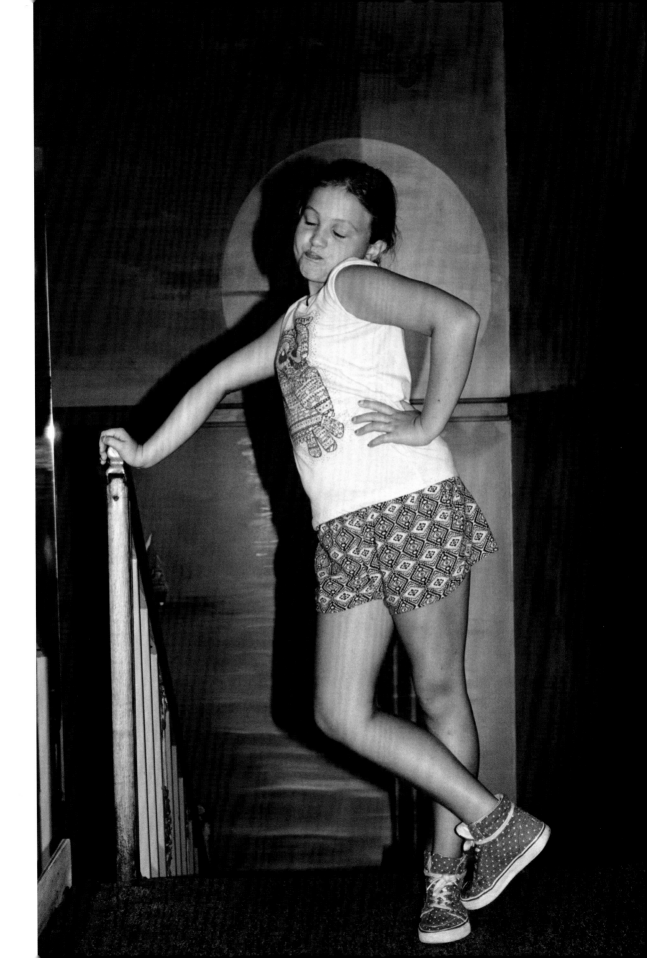

Good-bye, Daddy; hello, Mommy.

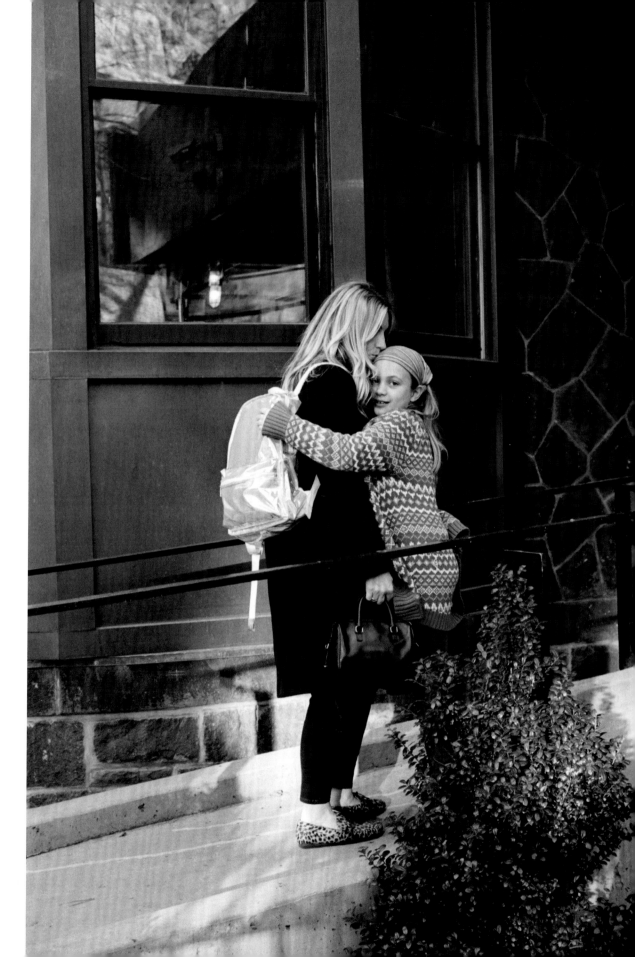

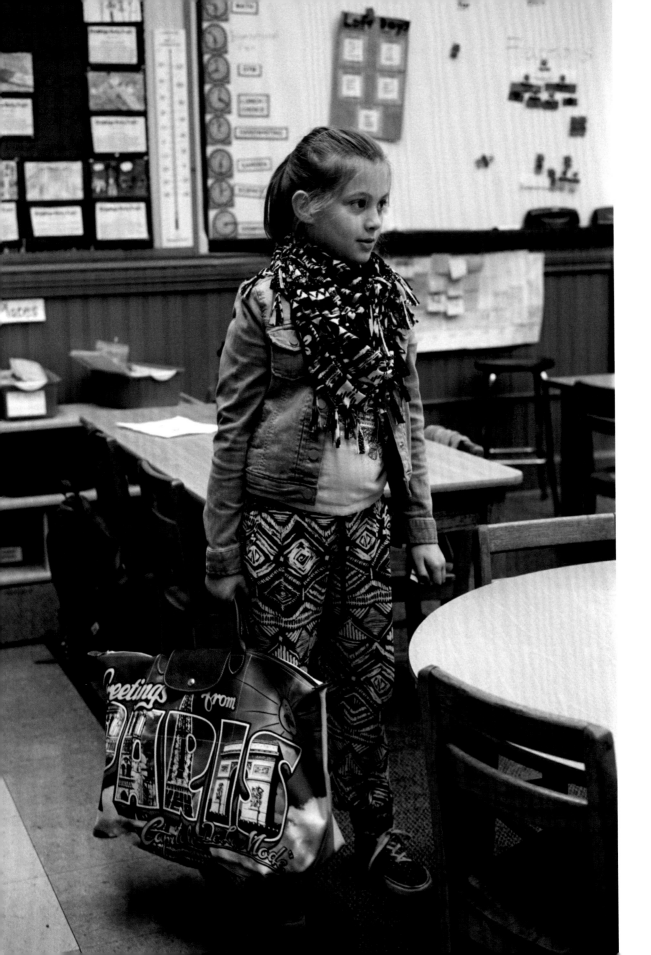

Second-grade thoughts.

Empty stadium in Berlin.

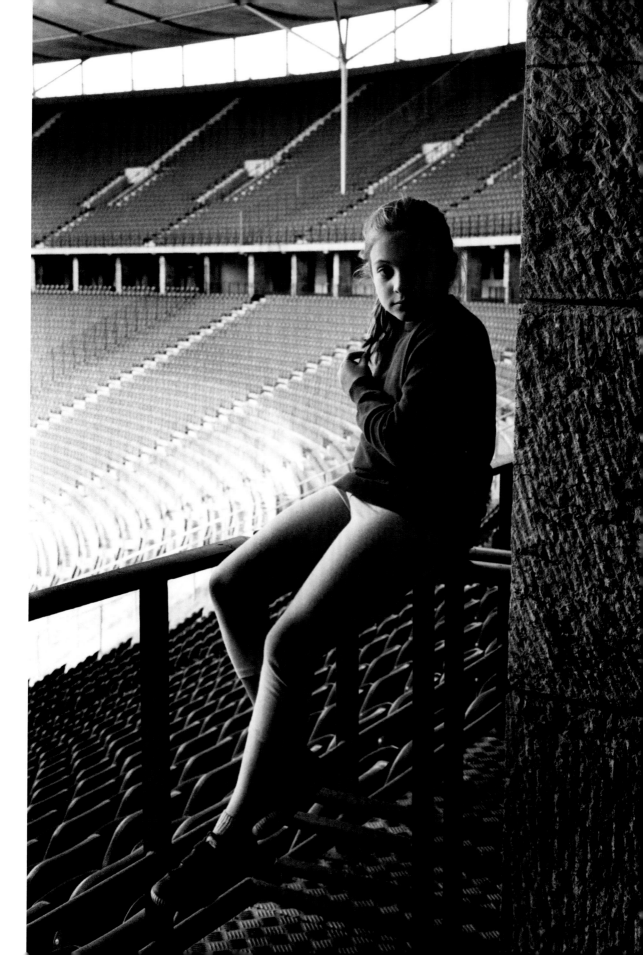

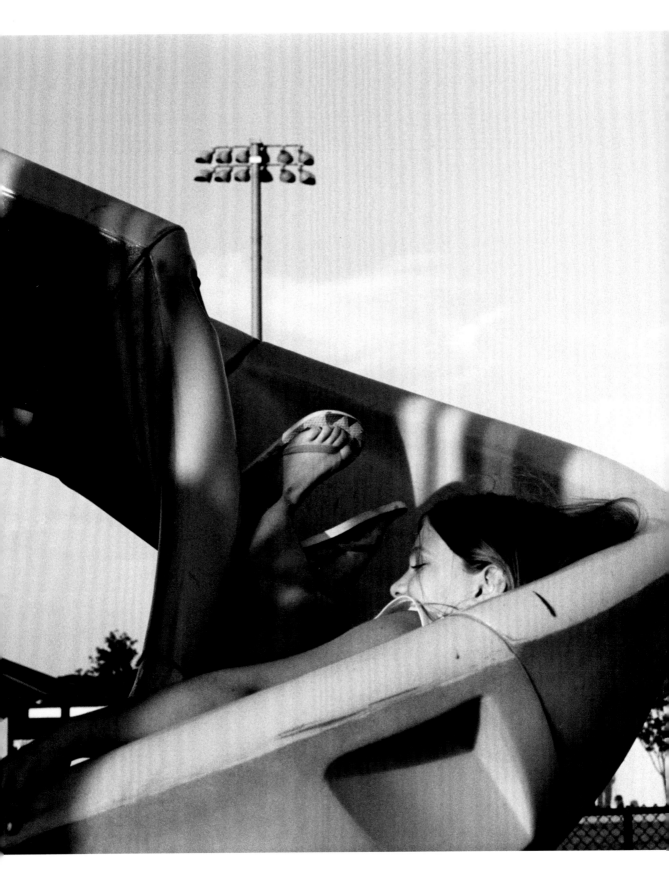

Sliding face-first down a rabbit hole.

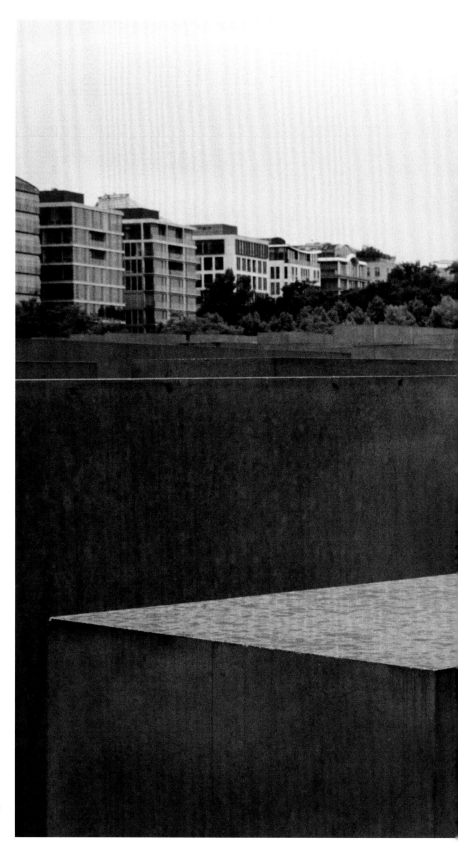

Making Daddy nervous jumping giant stones.

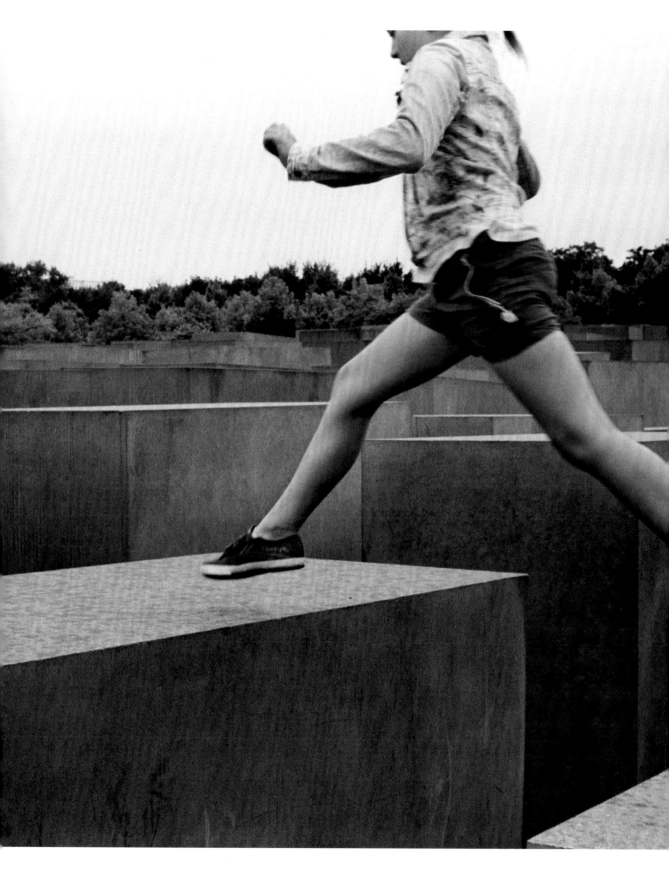

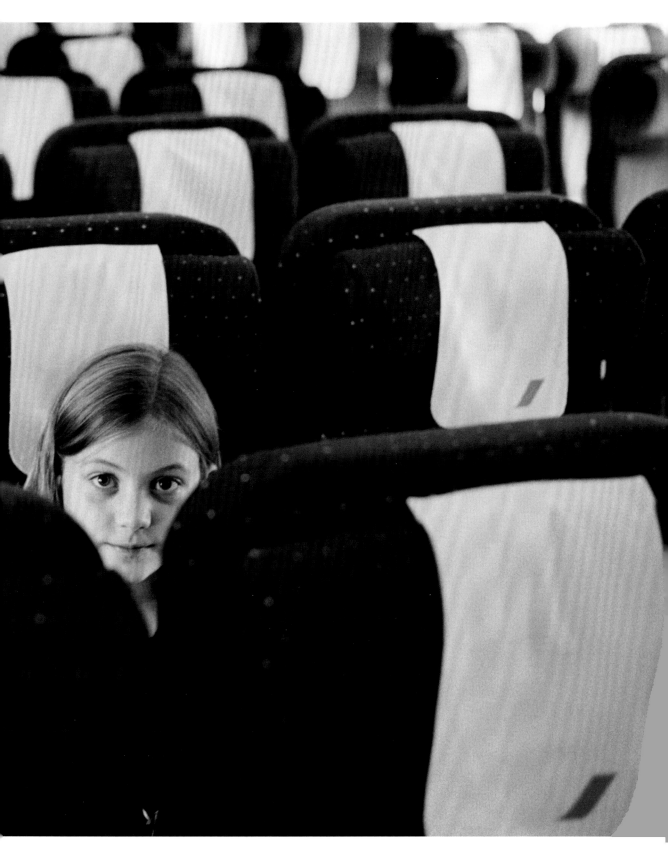

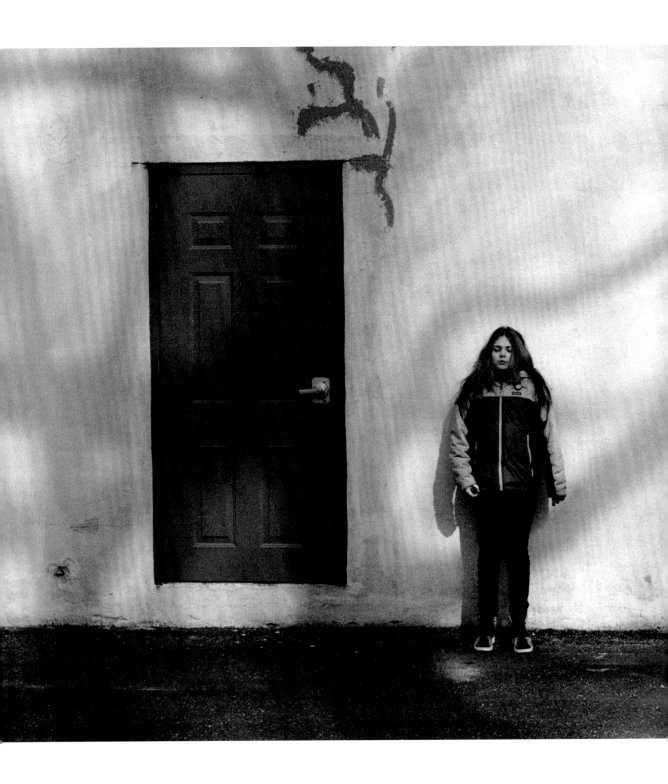

Do I have to choose?

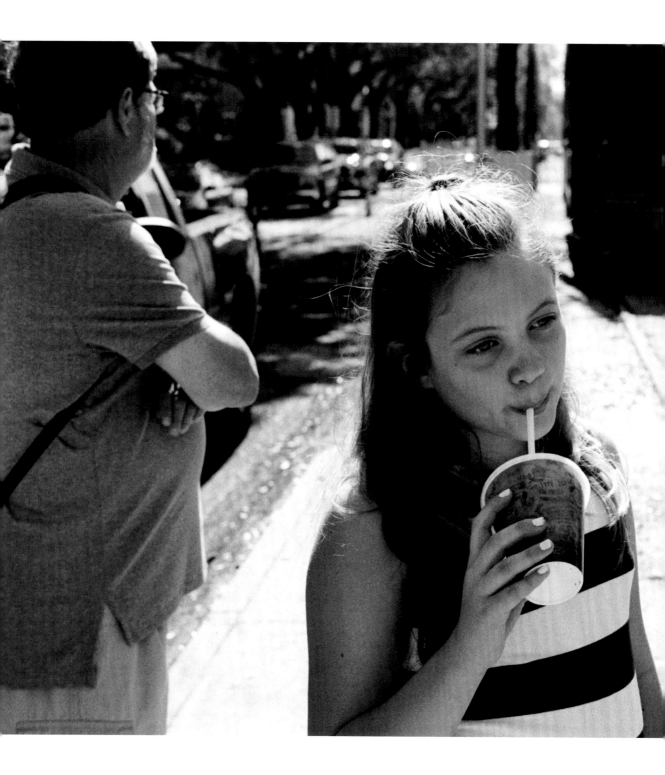

Waiting for the trolley in New Orleans with a much-needed lemonade.

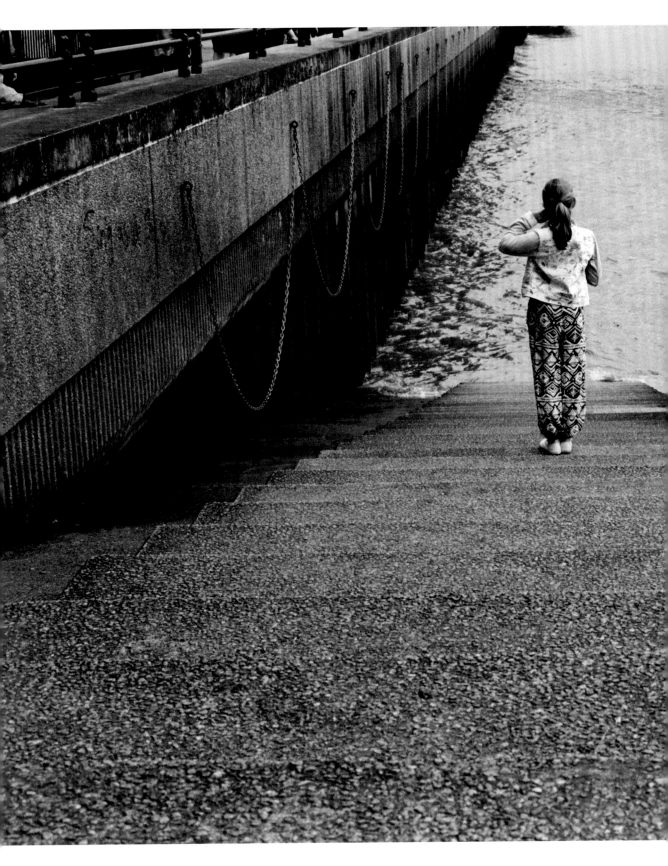

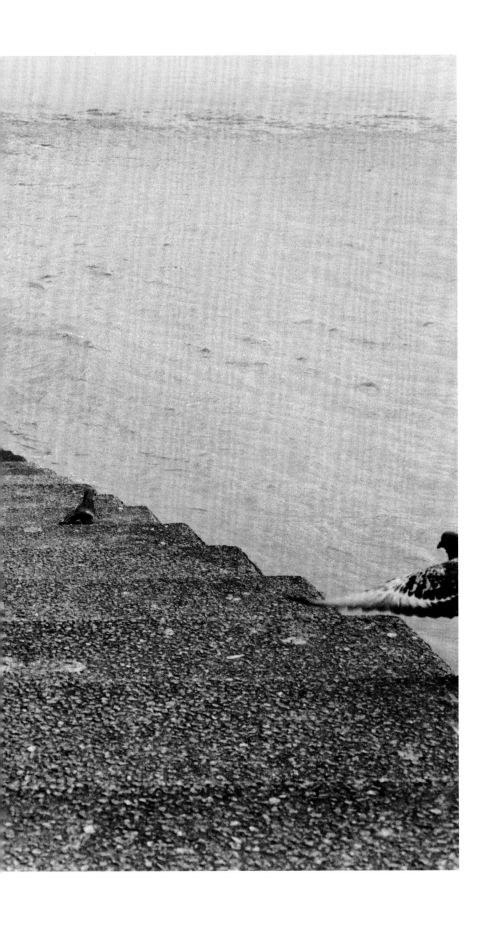

I wasn't crying, Daddy.

Broken in the car.

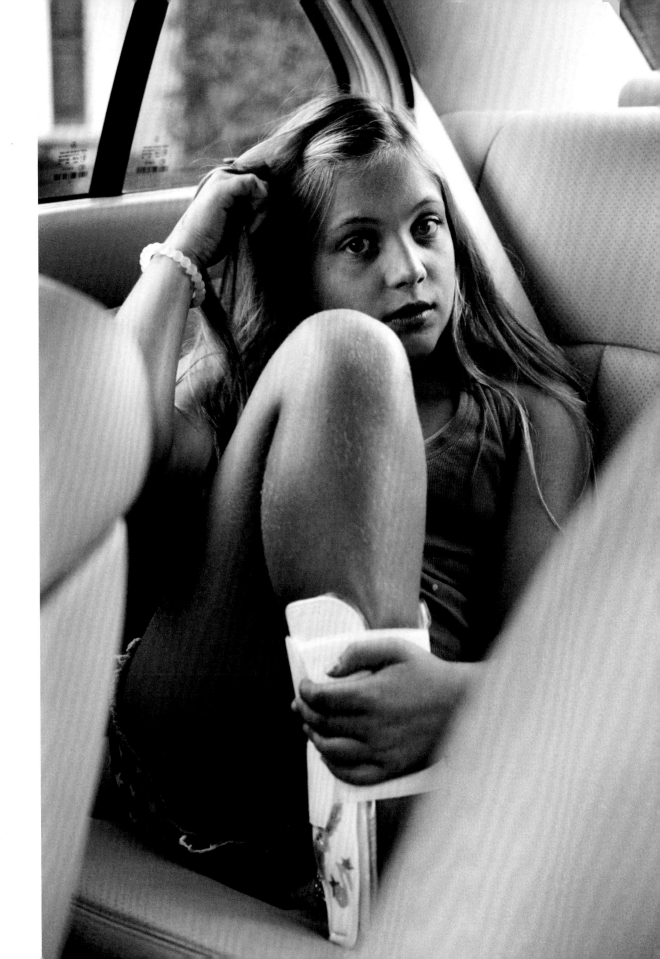

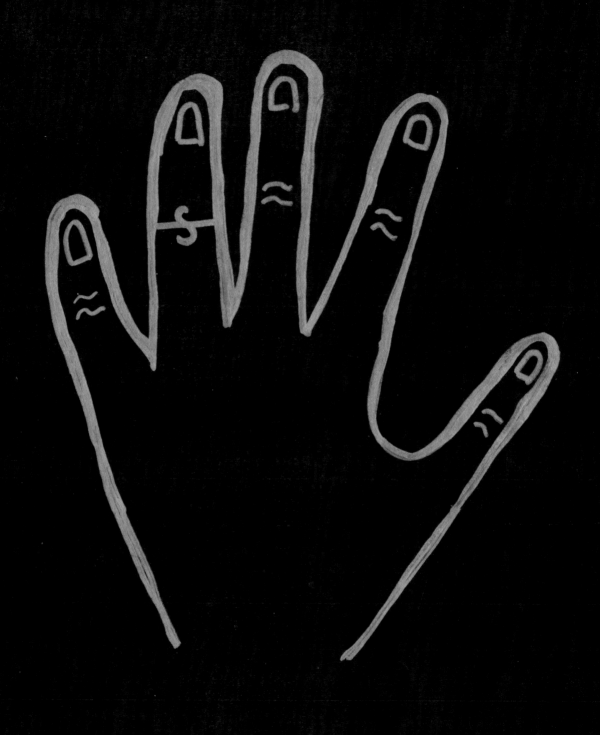

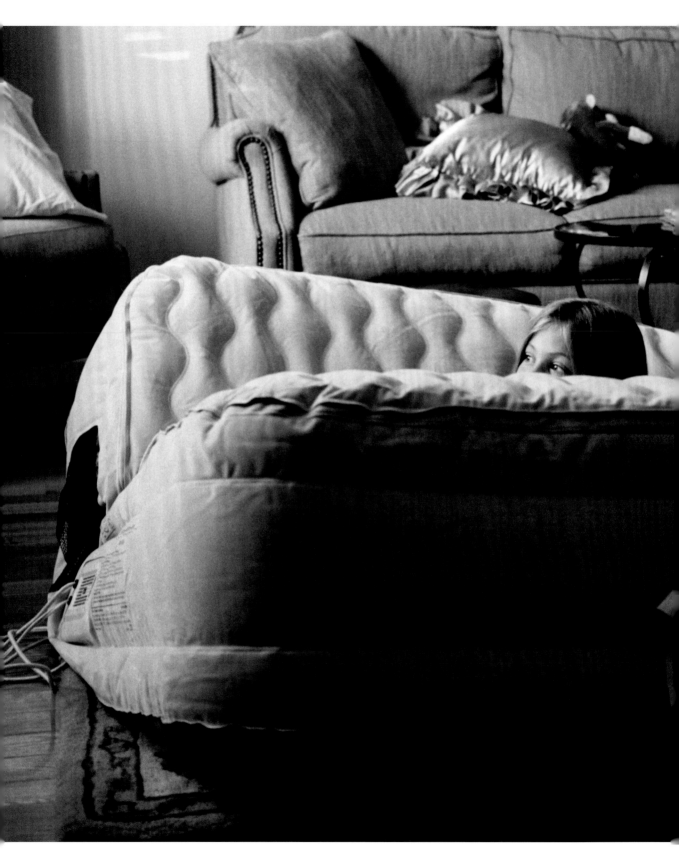

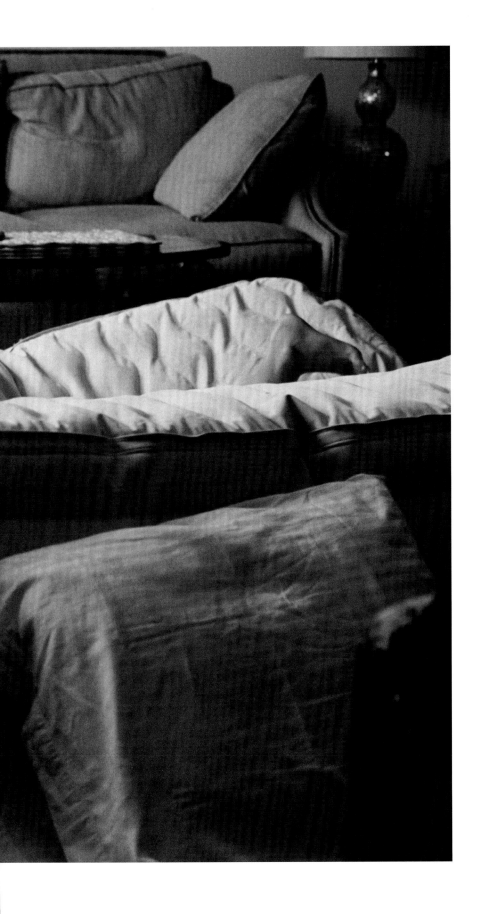

Daddy, it's deflating.

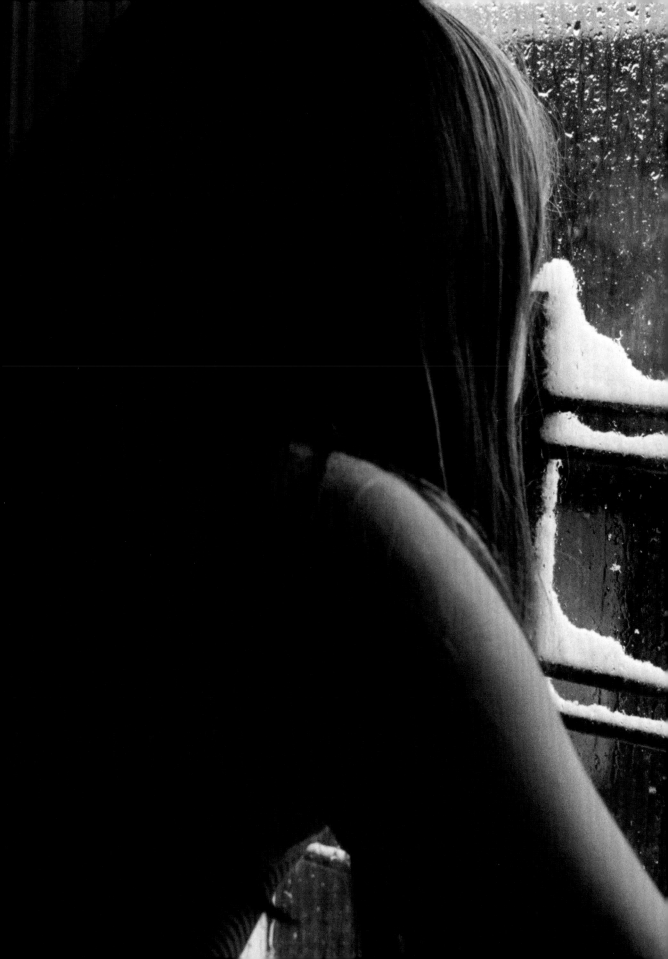

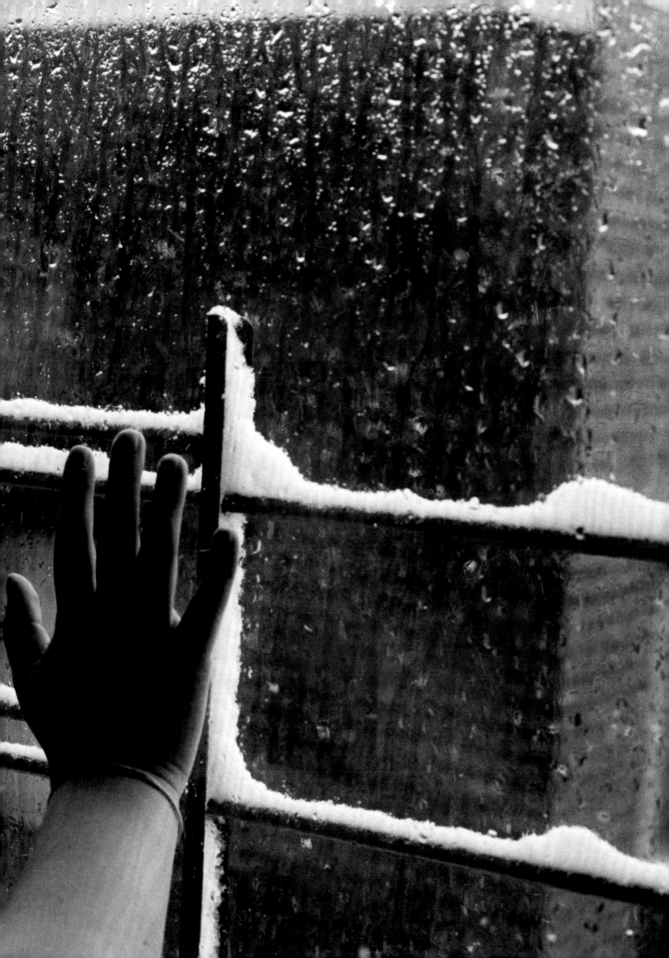

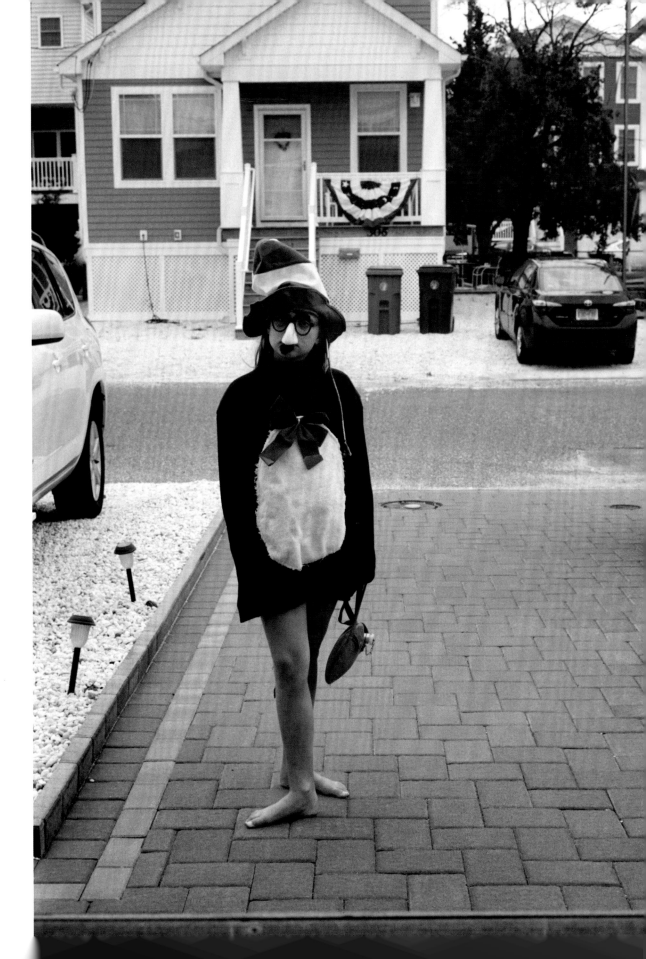

ROAR!

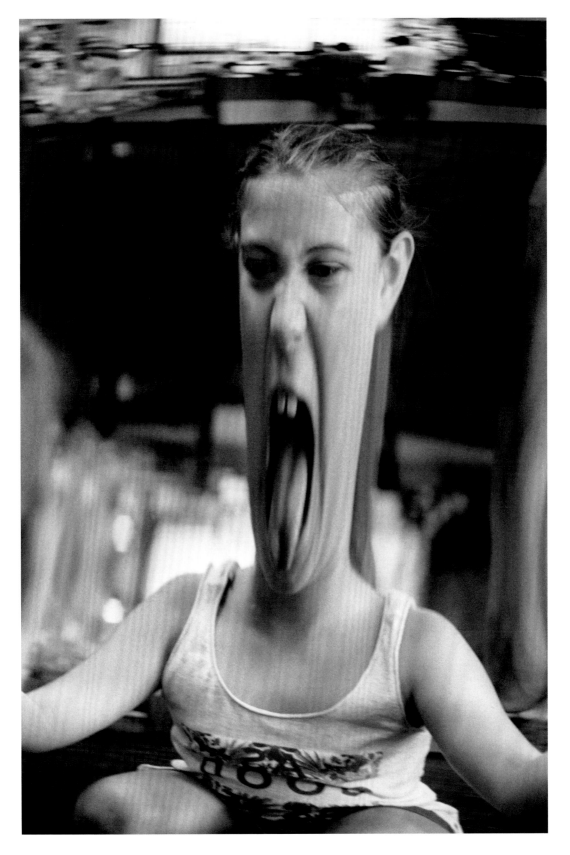

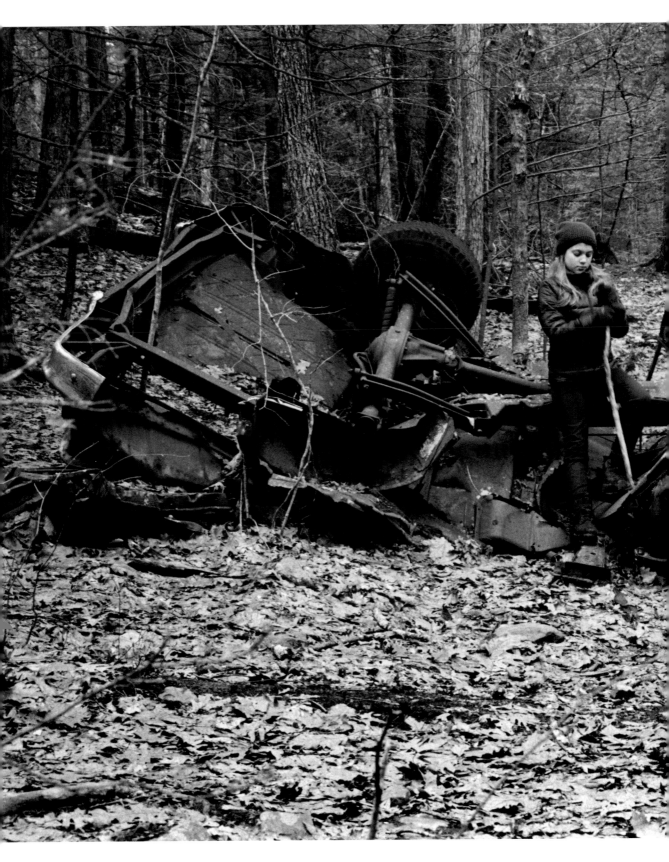

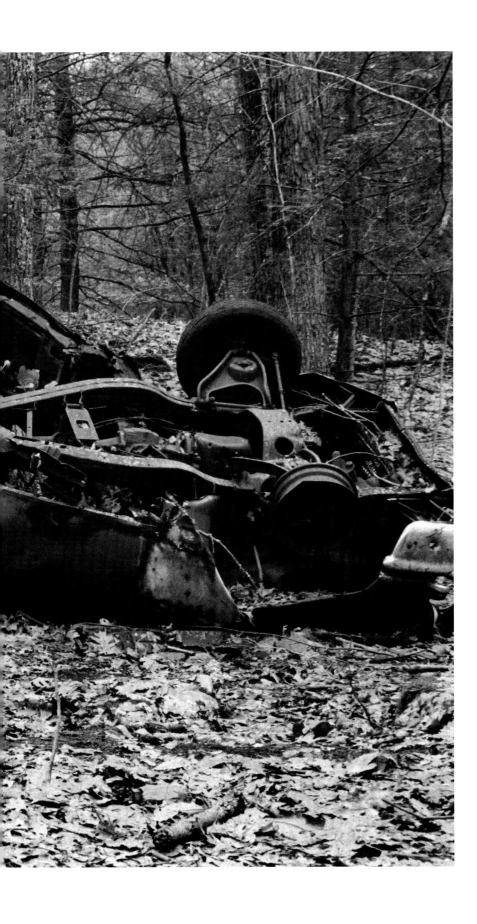

Scary car crash in the middle of nowhere.

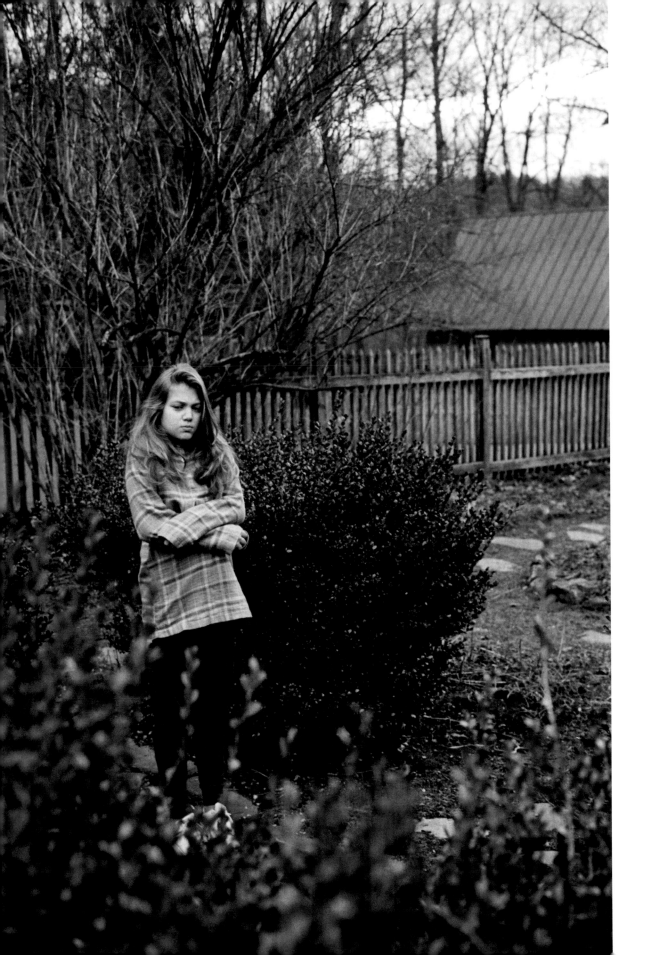

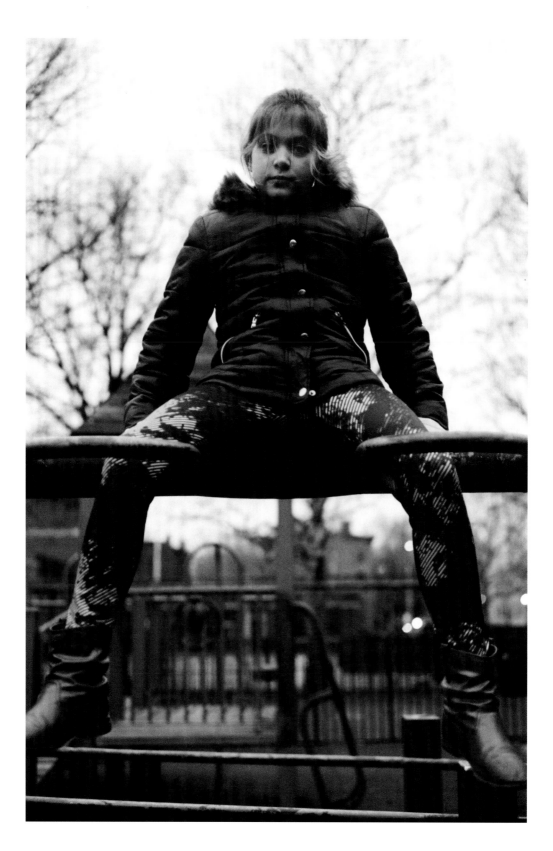

I was really proud to get up there without Daddy's help.

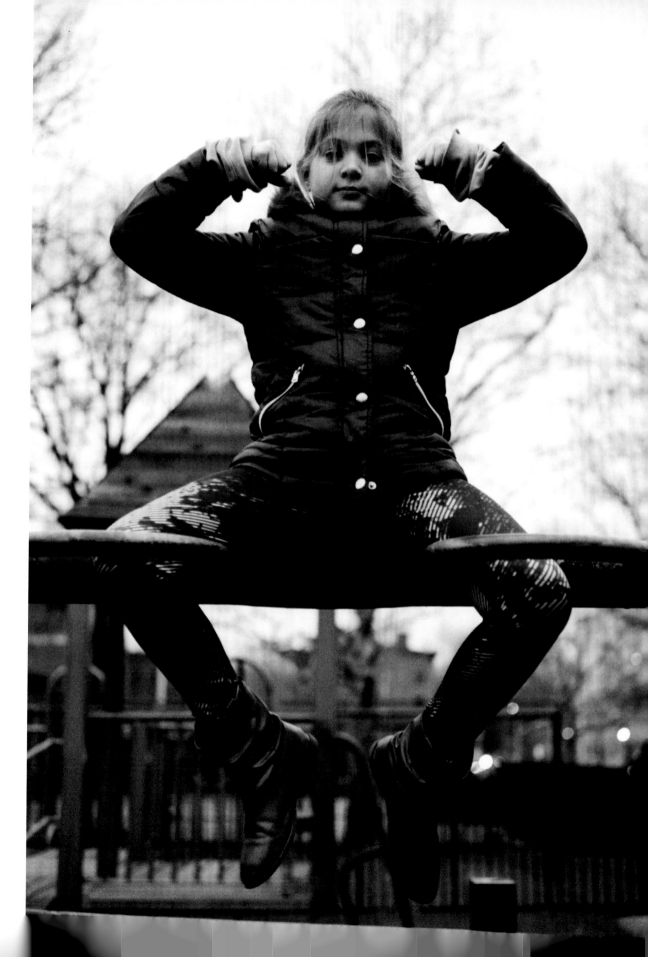

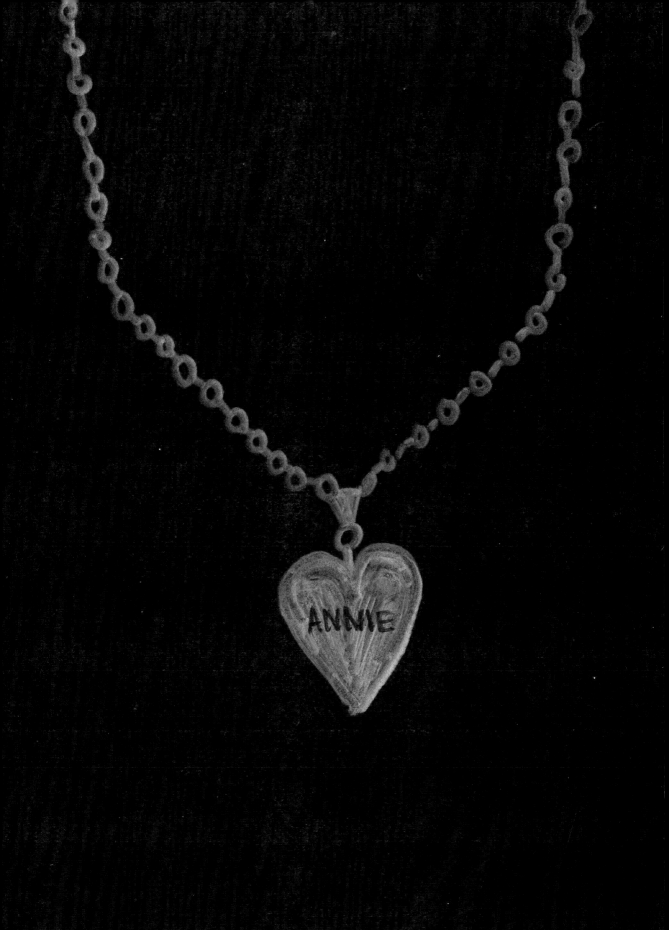

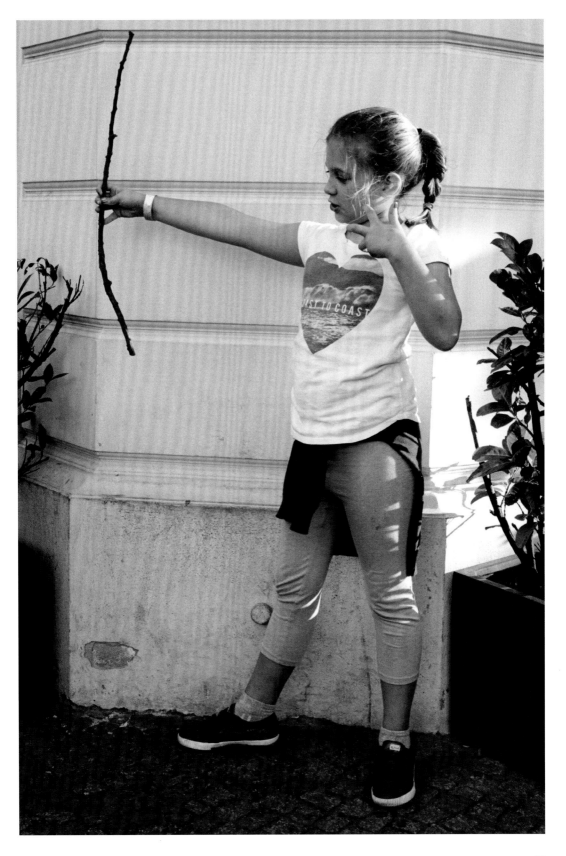

On the way to Daddy/Daughter day in Coney Island.

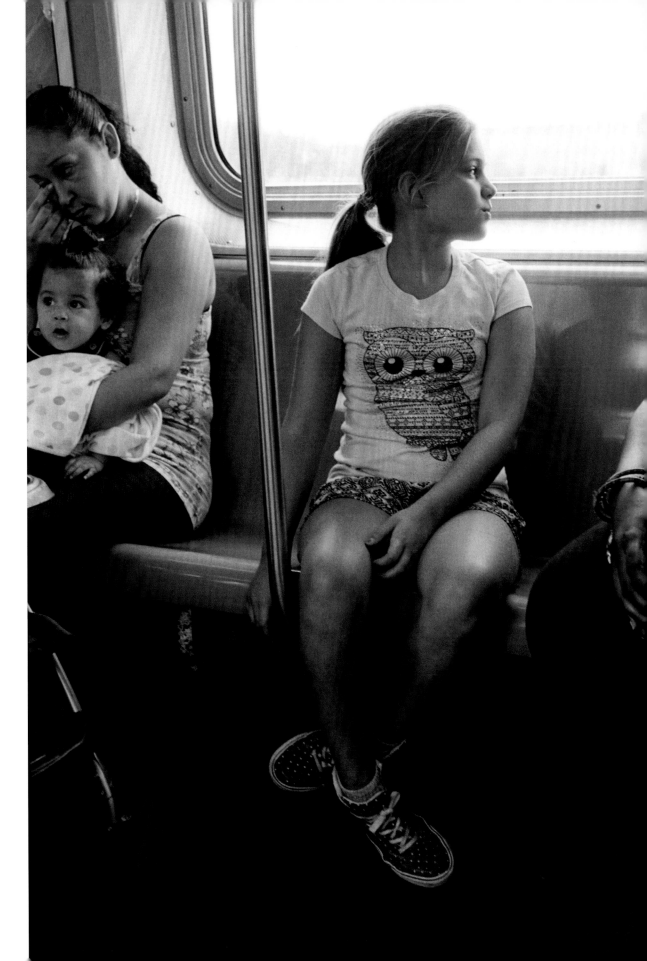

Waiting on Mommy, with ice cream.

Overleaf: Eating shaved ice next to Momma Swan.

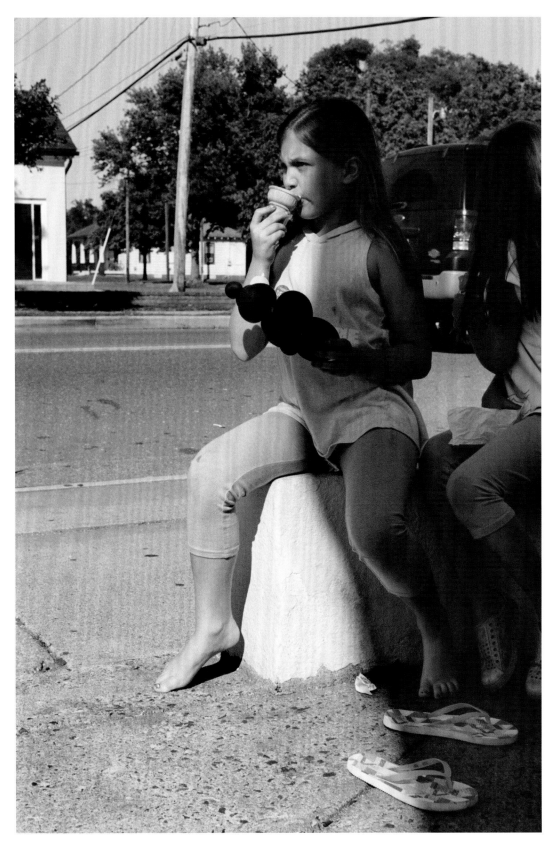

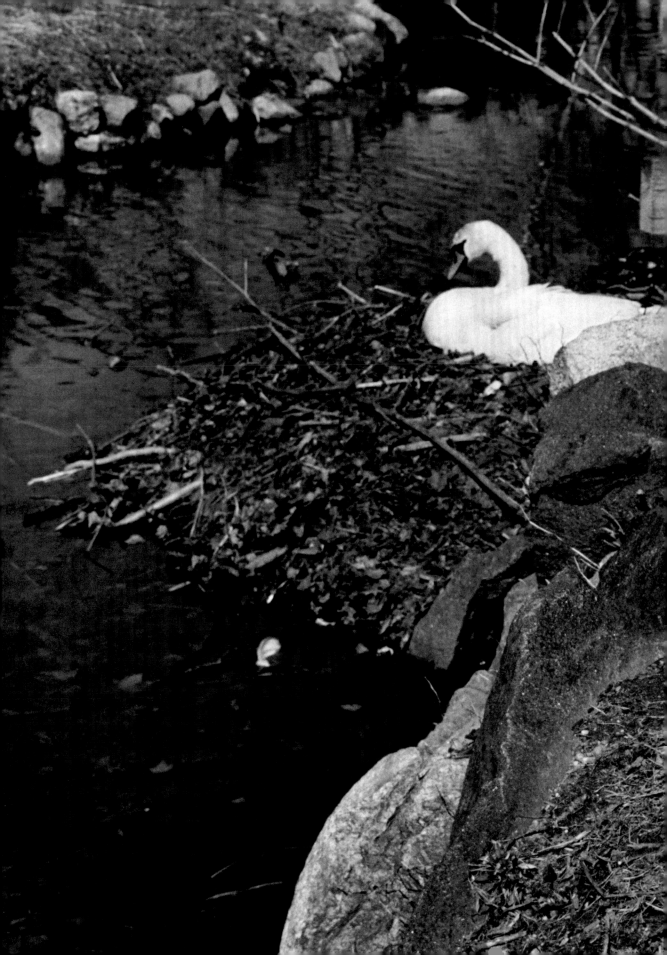

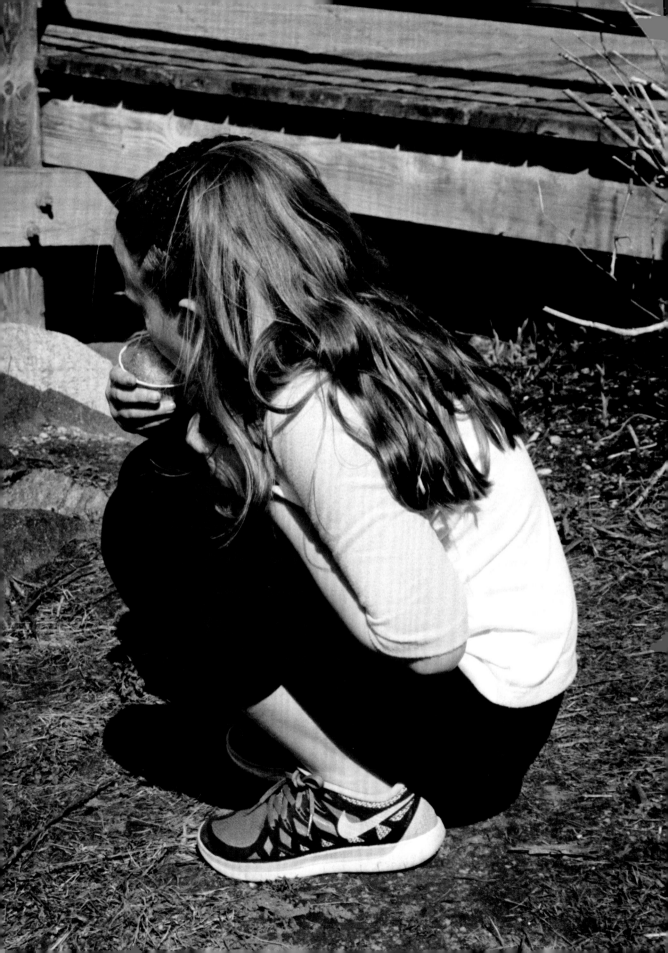

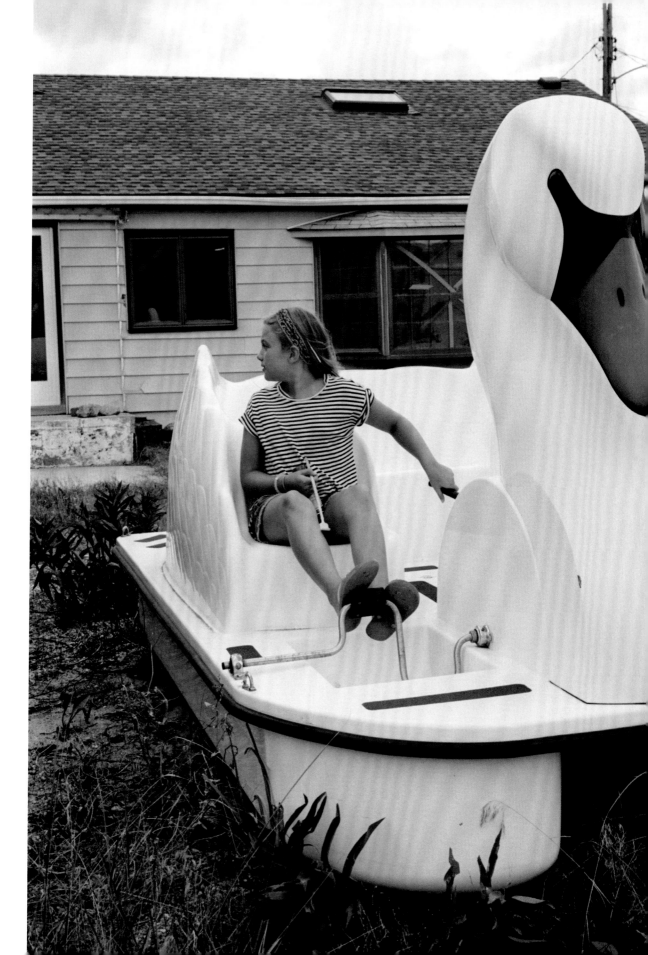

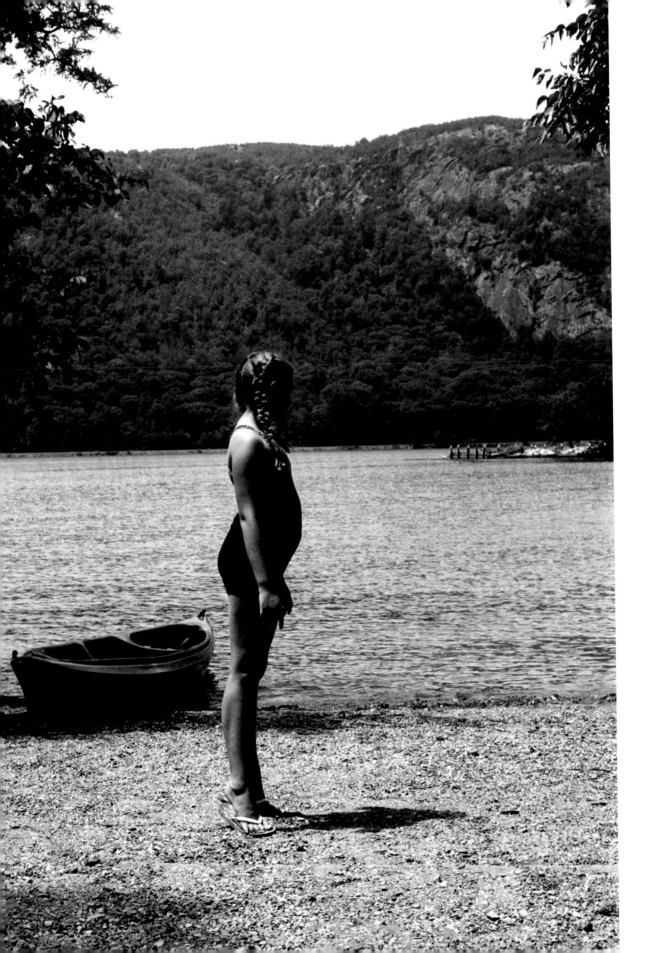

How do I get to the other side?

Ice cream makes me happy.

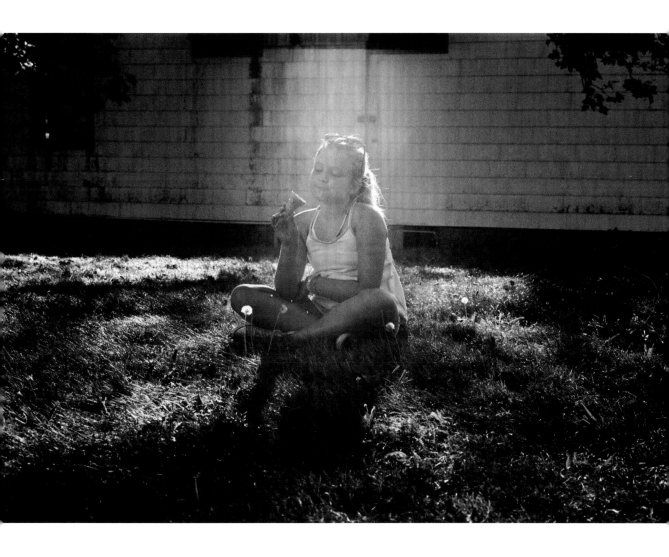

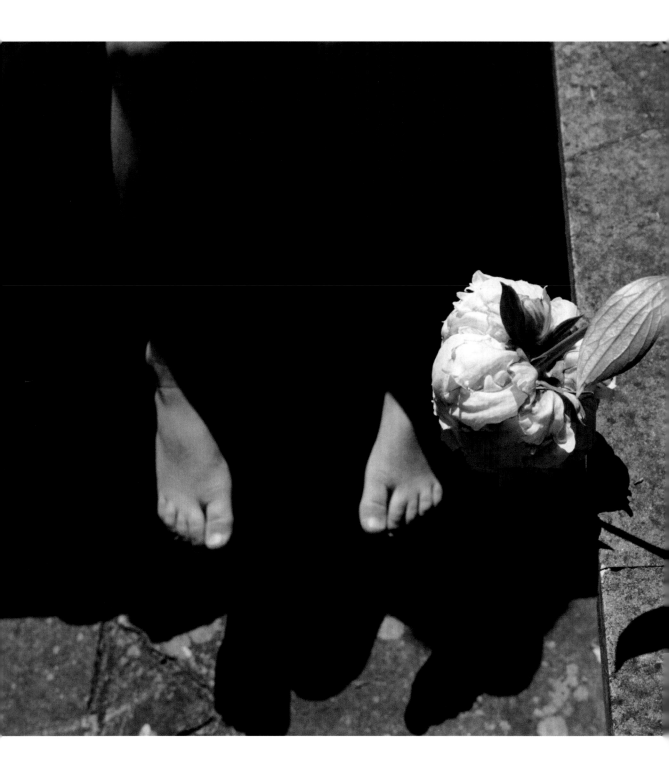

Mommy's favorite flower.

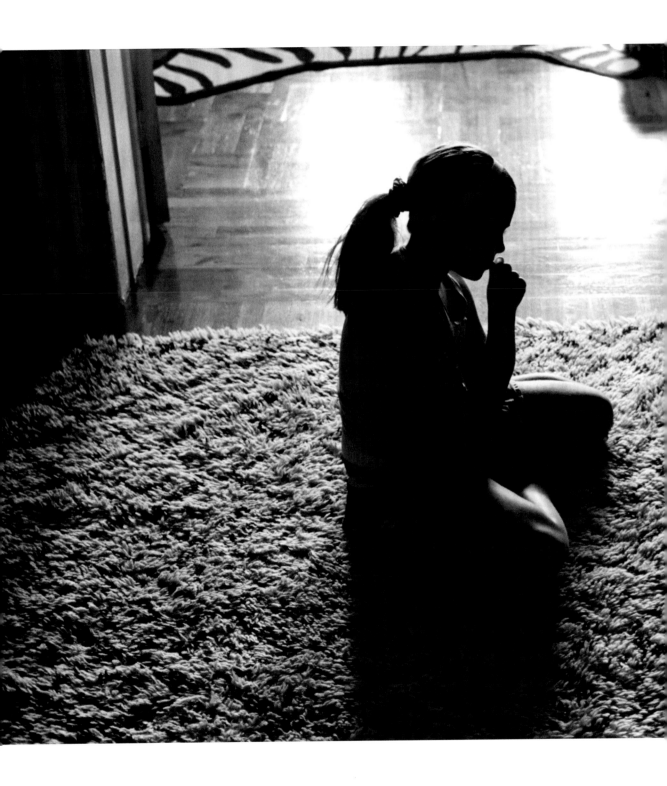

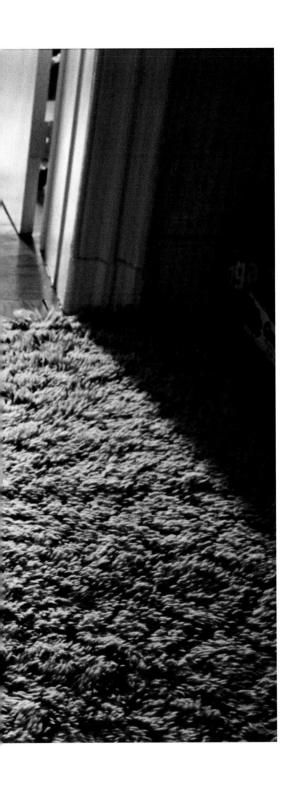

Getting to the other side.

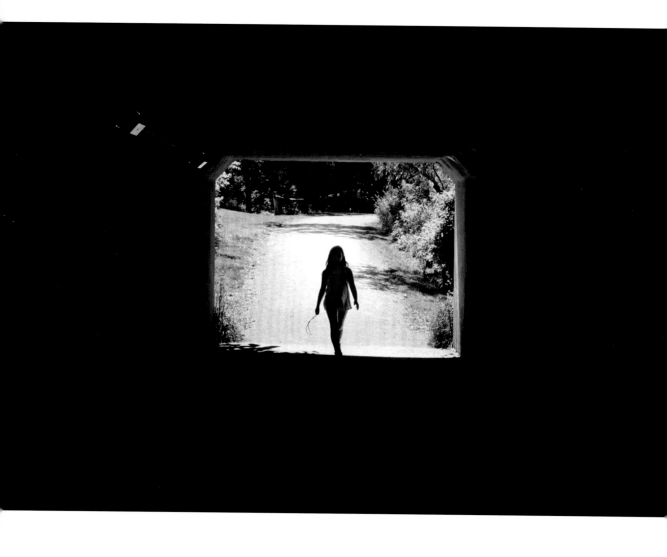

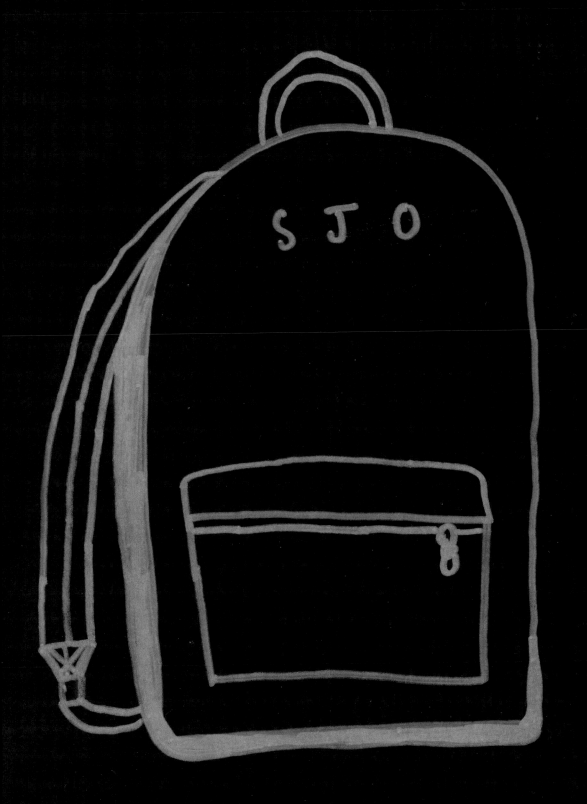

APPENDICES

Index

About the Author

Justin O'Neill is currently the photography director of *Esquire* magazine. Previously he was a photo editor at *GQ*, *New York Magazine*, and *The New York Times Magazine*. Justin is also a faculty member of the School of Visual Arts teaching undergraduate photography critique. He lives in Brooklyn Heights with his daughter Stella.

About the Contributors

Madeline Lippman is a clinical psychologist and psychoanalyst. She received her BA at Princeton University in English literature and creative writing, her first love. She went on to complete her PhD in clinical psychology at Adelphi and her postdoctoral training in psychoanalysis at New York University. She has also spent most of her career working in college mental health. Her areas of interest include loss and bereavement, young adult development, creativity, couple therapy, human sexuality, and integration of psychotherapy techniques. She is in private practice in New York City.

Born 1971 in Jerusalem, Israel, **Elinor Carucci** graduated in 1995 from Bezalel Academy of Arts and Design with a degree in photography, and moved to New York that same year. Her work has been included in many solo and group exhibitions worldwide, including Edwynn Houk Gallery, Fifty One Fine, Museum of Modern Art New York, and The Photographers' Gallery, London, and has appeared in *The New York Times Magazine*, *The New Yorker*, *Aperture*, among other publications. She was awarded the ICP Infinity Award in 2001, The Guggenheim Fellowship in 2002 and NYFA in 2010. Carucci has published three monographs to date, *Closer* (Chronicle Books; 2002), *Diary of a Dancer* (SteidlMack; 2005), and *MOTHER* (Prestel; 2013). She currently teaches at the graduate program of photography at School of Visual Arts and is represented by Edwynn Houk Gallery. She currently lives in New York.

ACKNOWLEDGMENTS

This book would have not been possible without the generosity and help from friends and family.

I am especially grateful to Fred Woodward for his guidance throughout this project, and for his contributions towards the design of this book.

Thank you, Elinor and Madeline, for your moving and thoughtful essays.

Thank you, Richard Fousler and Griffin Editions, for the exceptionally beautiful scans of my images.

The contributions made by the following people were also very instrumental in making this book happen, and to all of you I owe a deep debt of gratitude: Pari Dukovic, Tony Kim, Hugo Lindgren, Ash Carter, Marc Hom, Chris Buck, Kristina O'Neill, my mother, and my brother.

Thank you, Stella, my beautiful girl for being my best friend through this challenging time in our lives. I love you.